GEISHA

The Life, the Voices, the Art

JODI COBB

 ALFRED A. KNOPF NEW YORK 1995

I have changed the names of the geisha who were so generous with their time and their stories, and welcomed me into their lives during the last three years. To a Western mind, having your photograph published but your name changed may seem a contradiction. But it is a perfect example of the dichotomy at the heart of Japanese society—the gap, and sometimes chasm, between *tatemae* and *honne*, between your public face and your private inner thoughts.

THIS IS A BORZOI BOOK
PUBLISHED BY ALFRED A. KNOPF, INC.

Grateful acknowledgment is made to the following for permission to reprint previously published material:
Oxford University Press: Excerpt of poem by Ihara Saikaku, from *The Floating World in Japanese Fiction* by Howard Hibbett, copyright © 1959 by Oxford University Press. Reprinted by permission of Oxford University Press, Oxford, England. *Charles E. Tuttle Co., Inc.*: Poem (p. 103) from *Yoshiwara: The Pleasure Quarters of Old Tokyo* by Stephen and Ethel Longstreet, copyright © 1970 by Stephen and Ethel Longstreet; the geisha songs "She sulkily pretends to sleep . . .," "I bathed my snow skin . . .," "The night is black . . .," "I know she is light and faithless . . .," "Visitor this evening . . ." from *Comrade Loves of the Samurai and Songs of the Geisha* by E. Powys Mathers (Tokyo: Charles E. Tuttle Co., Inc., 1972); "Longing, Longing," "Spring Wind Whispers," "Waiting Anxiously," "Your Heart Flip-flops" (pp. 20, 32, 77, 92), from *Ko-uta: Little Songs of the Geisha World* by Liza Crihfield, copyright © 1979 by Charles E. Tuttle Co., Inc. Reprinted by permission of Charles E. Tuttle Co., Inc., Tokyo, Japan.

Library of Congress Cataloging-in-Publication Data

Cobb, Jodi.
 Geisha / Jodi Cobb.—1st ed.
 p. cm.
 Includes bibliographical references (pp. 78–79).
 ISBN 0-679-43774-6
 1. Geishas. 2. Geishas—Pictorial works. I. Title.
GT3412.C63 1995
306.74'2'0952—dc20 94-37663
 CIP

Manufactured in Singapore
First Edition

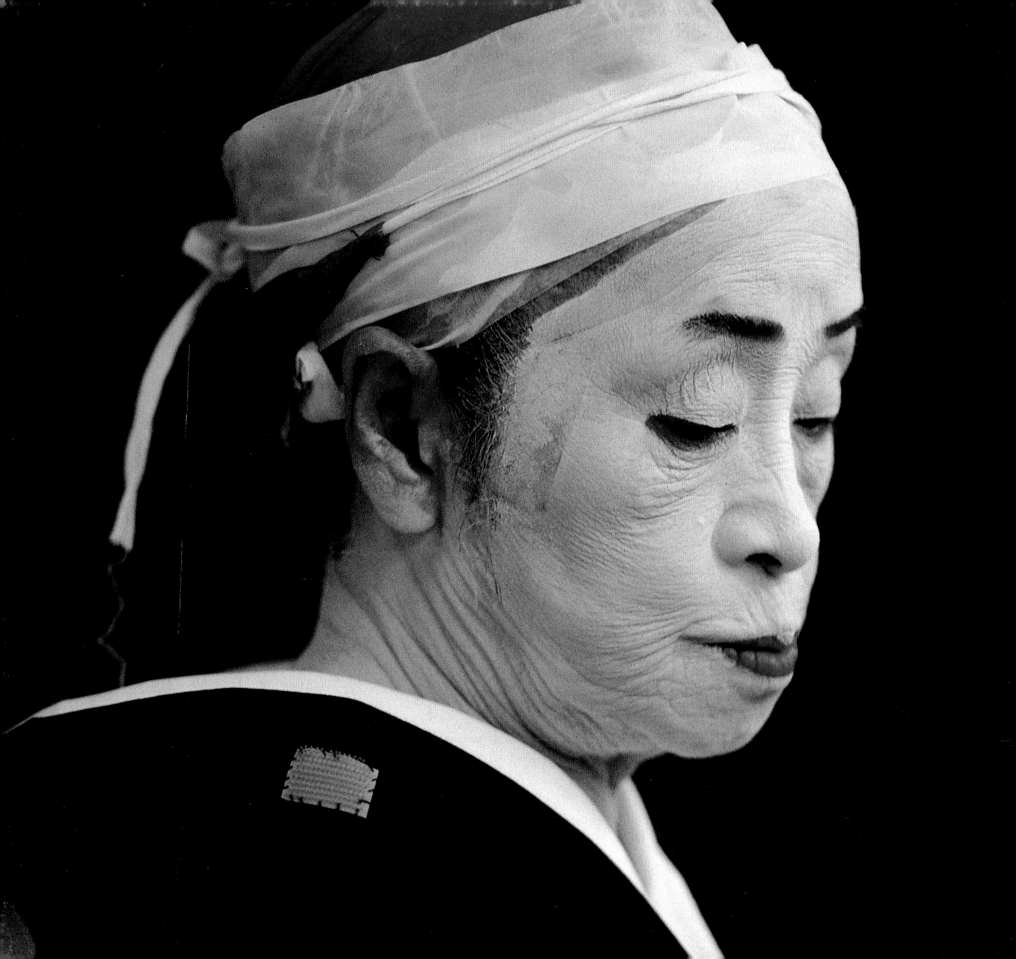

GEISHA

For my parents

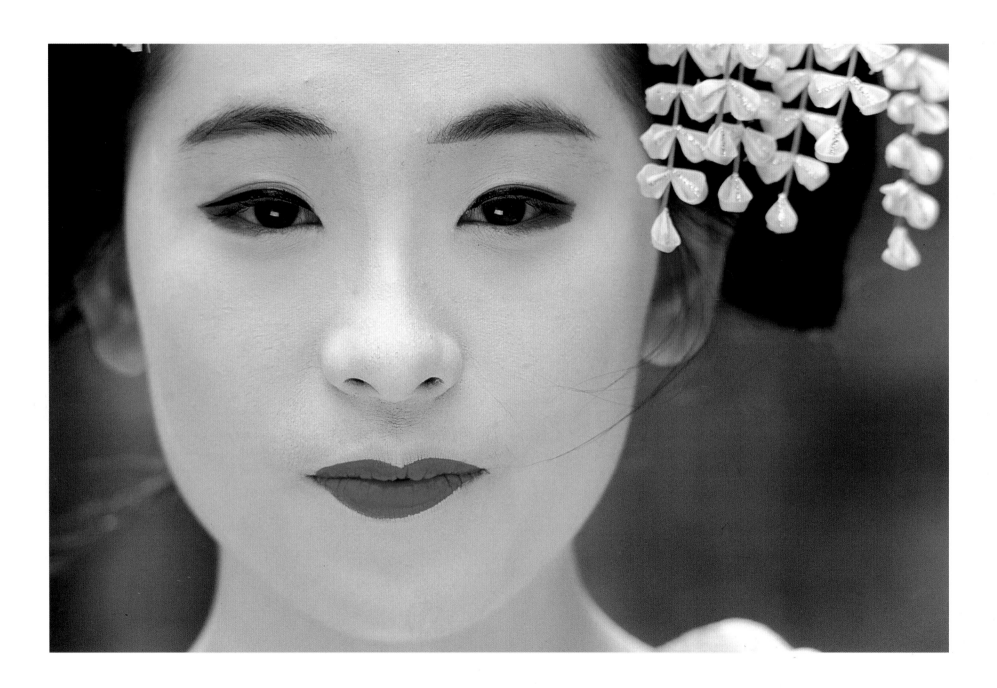

INTRODUCTION

by Ian Buruma

THE GEISHA, like the Chicago gangster or the English gentleman, is an emblem, something everyone, however uninformed about Japan, can recognize. Some Japanese find this irritating. They call this emblematic, foreign view of the country the "Fujiyama/geisha view." Sometimes they round out the stereotype by adding the *sakura*, or cherry blossom.

To simply reproduce an emblem, such as the geisha, as a pretty postcard image of Japan, would not be difficult. But to penetrate the surface, to enter into the closed world that exists behind the image of the geisha, and to show her in a way most of us have never seen before, that requires talent, persistence, and sensitivity of the highest order. That is why Jodi Cobb's photographs are a revelation: she has wrung something unique out of a cliché; she has brought a stereotype to vivid, well-defined life.

In Chinese or Japanese artistic tradition, by the way, there is nothing wrong with clichés as such. Japanese artists love cherry blossoms. And Chinese artists for centuries have painted stereotyped scenes, usually in the style of an old master. But the art does not lie in the subject portrayed. The true test of skill is to redefine the familiar.

Jodi Cobb has not done this in an obvious way. Consider, for example, the pictures of geisha dancing onstage. A lesser artist might have tried to break up the formalism of the geisha's art by distortion, weird angles, odd lenses. Cobb's pictures are straightforward. The performances are recorded from the point of view of the audience, rather than of some imaginary fly peering down from the backdrop. It is precisely from the center of the auditorium that we see the geisha at her most theatrical, most stylized. Any artifice on the part of the photographer would have diminished this effect. Like an eighteenth-century Japanese woodblock artist, Cobb has caught the performers in full pose.

Posing is an integral part of the geisha's performance, as indeed, of all traditional Japanese dance and acting. In classical—and much modern—Japanese theater, dance and acting are in fact the same thing. When Kabuki developed in the seventeenth century, its earliest female performers, who in actuality were also prostitutes, danced on stages erected by the riverside in Kyoto, very near some of the geisha establishments photographed by Cobb. The essence of Japanese dance-theater lies in the *kata*, or dramatic posture, which wraps up climactic scenes. Woodblock prints of Kabuki usually show an actor doing a *kata*: a warrior flinging out his arms and legs, rolling his eyes, trembling with emotion; a courtesan (or prostitute) bending her knees, arching her back, in a classic pose of erotic submission.

Woodblock prints often single out a star performer, isolating him or her from the rest of the action. But a *kata* is rarely performed in isolation. Especially in the case of women dancing, an individual pose is generally part of a larger scene, rather like a *tableau vivant*. In Cobb's photographs, the geisha look as disciplined as dancers in Busby Berkeley routines, except that Japanese dancers never smile. Insofar as this is possible in still pictures, Cobb shows the peculiar dynamism of Japanese dance, which comes, not from fast or fluid action, but from the tension between motion and absolute stillness.

The connection between stage acting and geisha entertainment goes deeper than the rather staid classical dance performances of today suggest. Not only were the first Kabuki actresses prostitutes, but so, subsequently, were the male actors who gradually took their place in female roles. Rich men (and sometimes women) would have the actors perform for them, and then ask them to stay on for more private entertainments. The brothels were located in the same licensed

areas as the theaters, and there was a constant *va et vient*—literally and artistically—between the two. Notorious love affairs between prostitutes and clients became the theme of many Kabuki plays, and the women in the brothels and teahouses copied the styles pioneered onstage. The fashion for critical booklets that assessed actors' performances was preceded by similar booklets reviewing the attractions of star courtesans and prostitutes.

The closest thing in the theater of the eighteenth and nineteenth centuries to the high-class geisha was the *onnagata*, the male actor of female roles. As is still true of the geisha today, the *onnagata*'s art is highly artificial—pure theater, one might say. It was never the idea to impersonate women realistically, but rather to express an idealized concept of femininity through highly stylized female mannerisms and behavior. This cannot be done by relying on physical charms. Indeed, the very absence of natural female beauty can be said to have helped bring the *onnagata*'s art to perfection. In the words of a famous eighteenth-century *onnagata*, "the ideal woman can only be expressed by an actor." And one may well say the same of the ideal geisha: a lady of a certain age, whose skill in performance, rather than her beauty, is her prime asset. Like the greatest *onnagata*, who can still play young lovers well into their eighties, the older geisha bear the patina of time.

Some of Cobb's finest portraits are of elderly geisha whose sagging mouths and wrinkled skin cannot be masked, but indeed are emphasized by their thick white makeup. The young geisha, and the even younger *maiko* (apprentice geisha) are beautiful, to be sure. The *maiko* is a stylized vision of unblemished virgin youth. In one of Cobb's most striking *maiko* portraits, the subject looks down modestly. Her skin has the texture and pinkish-white color of a delicate cherry blossom. In real life she might be a pimply adolescent, but in makeup and costume she is a picture of innocence before the fall.

The portraits of young geisha are less demure. The women look straight into the camera; they have already tasted life. Their skins are still smooth, but a certain individuality is beginning to shine through. Their eyes and mouths, however carefully painted, are, if not quite flirtatious, certainly knowing. They have the confidence of both beauty and experience. Nonetheless, it is the older women who look most interesting. Cobb has photographed them without their wigs; their hair is plastered down with tight bandages. The white makeup and crimson lipstick have been applied. There is nothing either innocent or coquettish about them, although, like elderly *onnagata*, they could probably still play any role to perfection. Instead, there is a kind of dark wisdom in their hooded eyes. Nothing human is strange to these women. To some this has lent an expression of tolerance and kindness; to others, a look of latent (or perhaps not so latent) cruelty.

Cobb's portraits show that the geisha is not only an artist, but also, so to speak, her own canvas. Like the puppeteers of the Bunraku theater, whose puppets' jerky movements first inspired the dramatic poses of Kabuki actors and courtesans, the geisha makes no effort to hide the art of her performance. It is on show to be admired. Cobb's pictures clearly demonstrate this: the photographer scrutinizes the mechanics behind the work of art. Actually, "behind" is not the right word, for the artifice is up front: the geisha is the puppeteer and the puppet at the same time.

We see the white and pink pigment being applied to the geisha's skin in close-up. We see a stubbly artisan's hand blacken the eyebrow of a *maiko*, much as a painter or calligrapher brushes his ink on a piece of rice paper. We see the crimson half-moon of a mouth, with tiny rivulets of red filling the tiny cracks. And we see mirrors, of all shapes and sizes. In these mirrors we see, among other things, a geisha, in dance costume, dabbing her forehead in a backstage dressing room; a vessel filled with lip-rouge, a bunch of red flowers, a hand stubbing out a cigarette; two hands applying cream to a hidden face, beside an altar with photographs of a deceased old man (a father? a patron?); a young geisha being fitted into her red undergarments in a dressing room cluttered with wig-boxes, a television set, piles of kimonos.

These pictures of backstage life stand in complete contrast to the formal photographs of the geisha onstage. The former are frenetic, messy, busy, detailed, not at all pretty, expressing perfectly the hectic atmosphere of dressing rooms (like kitchens) where performances are prepared. It is in these pictures that the girls and women clearly manifest individual personalities. Here, before they appear onstage, they laugh, they hug each other, they chat. Some look apprehensive, or expectant, or simply tired. Others read astrology charts in women's magazines. It is an atmosphere halfway between a girls' boarding school and a professional theater.

In these pictures, unlike those of the dance performances, the women often look isolated, lonely. They convey the sadness of the world of a professional performer. People who spend their lives dressing up, playing roles, "selling dreams," can only snatch moments to be themselves. For the geisha in this book, Cobb's camera was a silent witness to such moments. And through the same discreet, sympathetic eye, we catch glimpses of young, individual personalities gradually being transformed through white paint, powder and crimson lipstick into a stylized image of the ideal woman.

Ideals change with time, of course. As Jodi Cobb has observed in her text, the modern geisha is not at all the same woman as her eighteenth- or nineteenth-century sister. Premodern female entertainers formed a complex hierarchy, from the lowest streetwalker to the most refined courtesan, but most, in one way or another, engaged in prostitution. The word *geisha* was not used until the seventeenth century. The first entertainers to go by that name were in fact men, who amused the patrons of teahouses and brothels. But female geisha soon became more practiced in the arts of music, song and dance than their male counterparts, and were, moreover, accomplished enough in the amorous arts to threaten the livelihoods of licensed prostitutes. So a rule was instituted forbidding geisha to sleep with clients in the teahouses. Geisha, however, found ways to get around this prohibition, and they remained part of a world that was fashionable, erotic, theatrical,

but not in any sense classical. It was not until around 1870 that both Kabuki theater and geisha became staples of Japanese tradition.

In 1872, Ichikawa Danjuro IX, the greatest Kabuki actor of his time, dressed up in white tie and tails and made a speech (quoted in Thomas Rimer's book *Toward a Modern Japanese Theatre*): "The theater of recent years," he said, "has drunk up filth and smelled of the coarse and the mean. It has fallen into mannerisms and distortions and has been steadily flowing downhill. . . . I am deeply grieved by this fact and in consultation with my colleagues I have resolved to clean away the decay."

Kabuki, from then on, became the academy. And in time the same would be true of the most highly trained geisha. Geisha's double role as artistes and high-class prostitutes may have lasted, in some cases, until World War II, but certainly not after it. Bar hostesses, hot-springs "geisha," massage parlor girls and the like took over the lower end of the sexual market, and expensive call girls came to operate as the upper echelon. Today's geisha do not sell sex, at least not cheaply, or to any bidder; they have patrons, not tricks.

The geisha, like Kabuki, Bunraku, No, and indeed, *Nihonga*, or Japanese-style painting (as opposed to *Yoga*, Western-style painting), has become, as already noted, an emblem of Japaneseness. One method of preserving the forms of what was once merely fashionable and has since become tradition, has been to insist on drawing a clear line between "Western" and "Japanese." *Yoga* not only are painted in oil instead of ink but are often of such typically Western subjects as Parisian streets or women in European dress, whereas *Nihonga* commonly depict geisha, or cherry blossoms, or Mount Fuji. This distinction between "Japanese" and "Western" is now itself one of the clichés of twentieth-century Japan.

Again Jodi Cobb's sharp eye has managed to find gems on well-trodden paths. Some pictures present straightforward contrasts. Two posters are pinned side by side on a wooden wall: one shows Warren Beatty about to kiss his leading lady, a perfect image of modern, Western romance; the other is a picture of a *maiko*, performing a Kyoto

dance, dressed in kimono, arranged to reveal the nape of her whitened neck. Then there is the traditional wax-paper crimson umbrella, with a red Coca-Cola vending machine in the background. But the picture in which Cobb may have most beautifully captured the atmosphere of modern Japan is the one of a smiling geisha dressed like an Edo Period courtesan, parading in front of a crowd of onlookers and photographers. The white-and-black of a paper parasol, held high above her head, is reflected in what looks like a limpid pond in a Japanese garden, but is in fact the roof of a gleaming limousine. Here East and West are not so much in contrast as parts of the same modern Japanese world.

That Japan, despite the speed of modernization (or Westernization, if you prefer), has preserved so many of its artistic traditions, is of course remarkable. Perhaps this could not have been done without the attempt to maintain a rigid distinction between native tradition and modern, alien imports. But the unfortunate result of this dividing line has been the gradual fossilization of the country's premodern culture. Kabuki cannot be endlessly updated, adapted and reinterpreted in the way Shakespeare's plays are, or at any rate not nearly so easily. Classical Japanese culture, including the arts of the geisha, achieved its final, most polished form in the latter half of the nineteenth century.

Yet it is possible to exaggerate the purity of Japanese tradition. Many foreign imports—"Auld Lang Syne," breaded pork cutlets, whiskey and water—have become as Japanese as . . . the geisha. Cobb's photographs show how the borderline between Western and Japanese, old and new, is not as clearcut as one might think. Some geisha parties take place in the tatami rooms of traditional Japanese restaurants, but some are in Western-style establishments: expensive bars with leather couches and wood-paneled walls, and whiskey bottles and ice buckets on the tables. The only traditional element here is the geisha's kimono. As if to underline the modernity of such scenes, in contrast to the traditional stage performances, Cobb has often tilted her camera at odd angles and used long exposures to produce blurred movements which add a sense of speed and excitement.

There is nothing stilted or even genteel about these night scenes. A female hand slipping a pile of ten-thousand-yen notes into the kimono of another, while a male guest sits slumped over the table, presumptively drunk, makes it quite plain what fuels these entertainments. Not that anything so crass as money bills would ever change hands at the most elegant geisha parties—money would not even be mentioned. Even in the best establishments, however, formality tends to break down with drink. Conversations are full of sexual innuendo, and as a party progresses, the games played by geisha and clients become not only raucous but, to a Western sensibility, remarkably childish, as though relaxation necessarily implies regression. Admiral Yamamoto Isoroku, the man who planned the attack on Pearl Harbor, was a great lover of geisha parties. In a good mood he would do handstands, or tricks with food.

Some of Cobb's pictures of geisha and their clients convey an air of indulgent mothers coddling wayward sons: in the world of the geisha, boys will literally be boys. This throws an interesting light on the most tenacious cliché of all: the submissive Japanese woman. In the fantasies of many Western men, the phrase "geisha girls" conjures up images of almost doll-like complaisance. The Japanese idea of the geisha is rather different. Even in premodern Japan, the geisha was far from a mere plaything. The idea of the geisha, then as now, has always been much more complex.

A Japanese actor once told me that all actors are masochists. He was being extreme, but I could see his point: Playing a role to feed the fantasies of an audience can be a form of masochism. Yet it is also a source of power. The one who manipulates another person's dream exercises thereby a degree of control. This is also true—indeed, especially true—if the manipulator sacrifices or suppresses his or her own desires. Japanese men have long idealized, in Kabuki plays as well as the movies, the geisha and the prostitute as figures of sacrifice, which is not quite the same thing as submission. For, as the geisha

Mayumi remarks to Jodi Cobb, sacrifice can be a source of strength.

In premodern Japan, one of the ground rules of brothel and teahouse entertainment was that playing had to remain just that: playing. No matter how intently men sought to satisfy their romantic yearnings in the company of female entertainers, it was considered not only bad form but positively dangerous to mistake the elaborate forms of teahouse courtship for real emotions. For it was the underlying purpose of the licensed pleasure quarters, their raison d'être, to safeguard conventional family life by serving as an outlet for unrequited longings and desires. Real love between prostitute and client threatened the social order; men might forget their family responsibilities. But of course, men did sometimes fall in love with ladies of pleasure, and vice versa. And in reality, as well as in Kabuki plays, it was almost invariably the woman who ended by sacrificing her feelings, or even her life.

What is interesting, however, is that the women making such sacrifices in plays and films are not depicted as submissive or weak. On the contrary, it is the men in these affairs who are portrayed as weak, and almost childlike in their dependence on the women. This is partly because these stories were often meant to serve as morality plays, as warnings to men not to stray from the accepted norms of behavior. But the idea of the sacrificial woman as tough, maternal and independent, and the male as hopelessly feeble and irresolute, also reflects the mother-worship that is never far below the surface in Japan. It is still visible in modern Japanese films and novels, and in many of Cobb's photographs.

One of the most remarkable images in the book is the series of three photographs in which an older man attempts to pluck a cherry from the mouth of a handsome middle-aged geisha. She has tied the stem into a knot with her tongue and his efforts amount to stealing a kiss of sorts. It is a common little parlor game in Japan's "water trade." What gives the pictures their distinctive flavor is the facial expressions. They are hardly inscrutable: the woman is clearly in control. She teases her man, first avoiding his pursed lips, then finally granting him a peck on the mouth. His expression is far from being rakish or roguish, let alone macho; it is more like that of a child grateful for being allowed to play an adult game.

None of this is to say that Japanese males are never macho, or women never submissive. In public life, women have been oppressed for centuries. And until a few decades ago, becoming a female entertainer did entail real sacrifice, not only of a family life but of a private life altogether, even if it was sometimes true that, in Kurt Singer's words—in his book *Mirror, Sword and Jewel*—"[it] is in the style of their self-abandonment that [geisha] are granted a degree of self-determination denied to ordinary members of the human hive."

And yet, even that has changed. Nowadays it is Thais and Filipinas who abandon themselves to the Japanese pleasure trade in order to help brothers through school or to keep their families alive. Japanese women who become geisha, or hostesses, today—far more than was the case when Singer wrote about the fate of courtesans and geisha in the 1930s—do so out of free personal choice. They opt for the water trade because it frees them from other responsibilities. So far from being the simpering tools of men's desires, modern geisha have taken on a traditional form to strike out on their own, to become unassailable. There is dignity in that. And this is the quality that Jodi Cobb has captured in the pictures that follow.

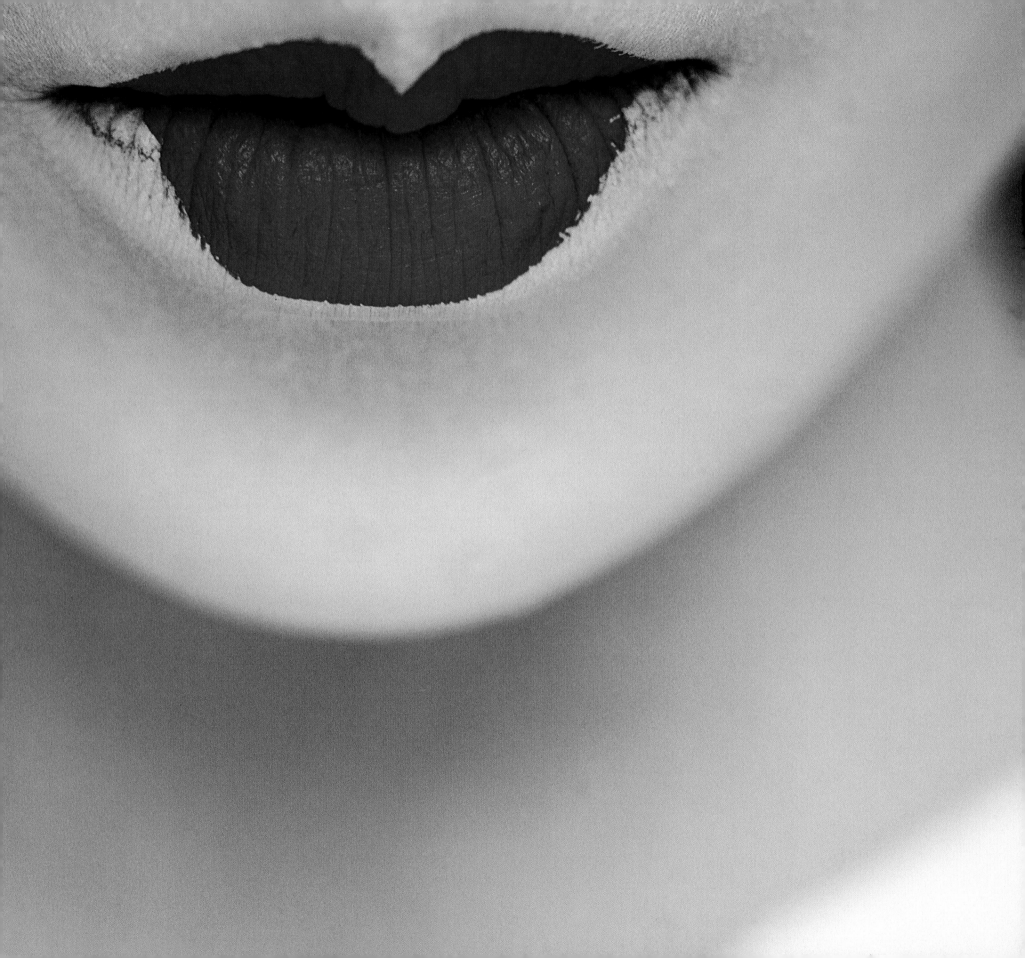

GEISHA

THE GEISHA DISTRICTS of Kyoto present a blank face to the world. Seamless rows of aged wooden façades, tiny two-story houses whose bamboo shades blind the windows, block any glimpse inside. The world of geisha does not give up its secrets easily.

Once, walls and moats denied entry to unknowns and exit to its captive women inhabitants, who were virtual prisoners, sexual slaves. Now, strangers may wander these streets, but without an introduction they would never dare enter the restaurants and teahouses where the geisha entertain. Geisha and *maiko* (apprentice geisha)—brief flashes of color glimpsed in doorways and limousines—do not acknowledge the existence of passersby. As dusk falls, serious black cars dispatch dark-suited gentlemen who disappear inside, slipping off their shoes at the doorway. Linen curtains shield the interiors from the curious. Nothing inside is visible from the street.

It is a formidable barrier for a photographer to penetrate. The geisha's impassive white mask reveals little emotion, whether of welcome or disdain. Her strict code of silence and fierce protectiveness toward clients conspire against revelation. The young girls in training are fearful of their elders, afraid of doing the wrong thing. The elders, steeped in their tradition of secrecy, have—one younger geisha told me—hidden things even from themselves. They have lost touch with their own feelings. They are armor-plated.

Enter Yuriko. She is the *okamisan* (proprietress) of a prosperous and popular geisha house that, with four *maiko*, two geisha and two twelve-year-old *tamago* ("eggs"—the youngest trainees), seemed more like a college dormitory than a residence of the demimonde. She would pull out her photograph album at any opportunity, her pudgy fingers caressing the pictures of past loves and proudly pointing to her younger, prettier, slimmer self on Hawaiian beaches and on boats in Sydney Harbour. Worldly and gregarious at forty-eight, vast of wit and heart, she was appalled by the image abroad of Japanese as stiff, serious, formal workaholics. Eager to show Japan's warm side, she opened her daily life to my camera.

Yuriko claimed a spiritual power to heal, and when she thought me in pain from carrying heavy camera equipment or spending too much time on my knees in the tiny rooms of geisha houses, she would cure me with neck and foot massages. I was not the only one she healed. People drifted in and out of her geisha house day and night. Clients, neighbors, friends, ex-geisha and *maiko* all came to be renewed by her energy and compassion.

And in Tokyo I met Mayumi. A dancer in one of Tokyo's most prestigious geisha districts, she is comfortable with foreigners, though weary of their misperceptions of her profession. She spoke only a few words of English, but with sign language and her own version of charades, she led me through the intricacies of geisha behavior. She taught me what gifts to give to whom, for one must never show up anywhere empty-handed. And when she thought I wasn't bowing low enough to some exalted person, she would reach over with her tiny, perfectly manicured hand and push my head all the way to the floor.

A fragile, flirtatious beauty at fifty-four, her soft cultured voice belied the strength of her convictions. Mayumi wanted the world to see the worth of these women whose lives had been hidden for so long. She pried open the door inch by inch, arranged introductions, persuaded reluctant geisha to participate, took me places I never thought I would see. When the conversations seemed the most stern, the most serious, when others seemed the most doubtful, and I would think all was lost, she would look at me and say, "Now take pictures!"

Through Yuriko and Mayumi, I came to my conviction of the nobility of the geisha.

I stopped briefly at other convictions: that they were tough businesswomen living off wealthy men, or hapless girls trapped into a life of subservience, or naughty women trading sexual favors for material gain; that they were coldblooded romantics, organized fakes, gorgeous fossils.

But as I discovered the women behind the masks, I came to know their truth. Until Japan's economic boom of the last twenty years, most women entered the geisha world through misfortune, not choice. At the heart of almost every

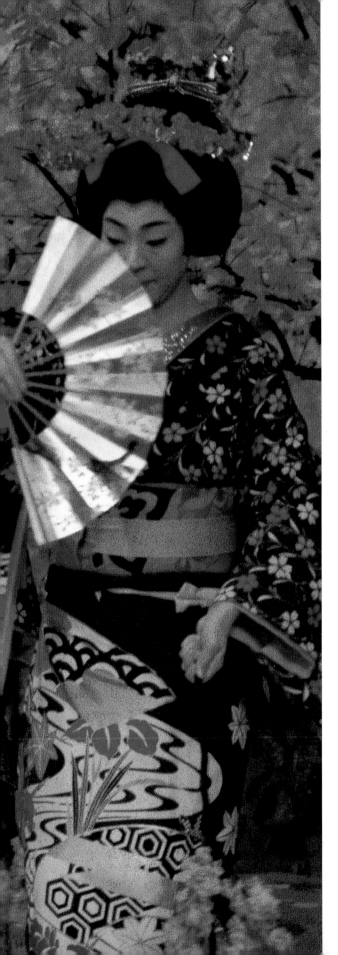

A WORLD
OF ART

"A geisha contains her art within herself, and because her body has this art, her life is saved. That is the power of art—the salvation of one's soul."

—Mayumi, geisha

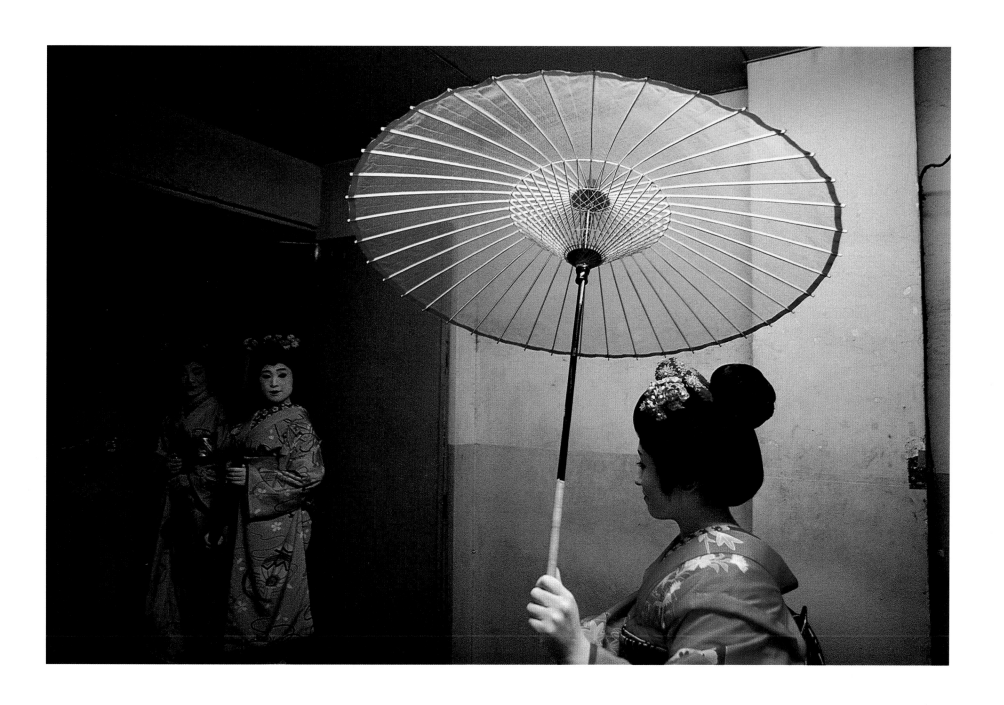

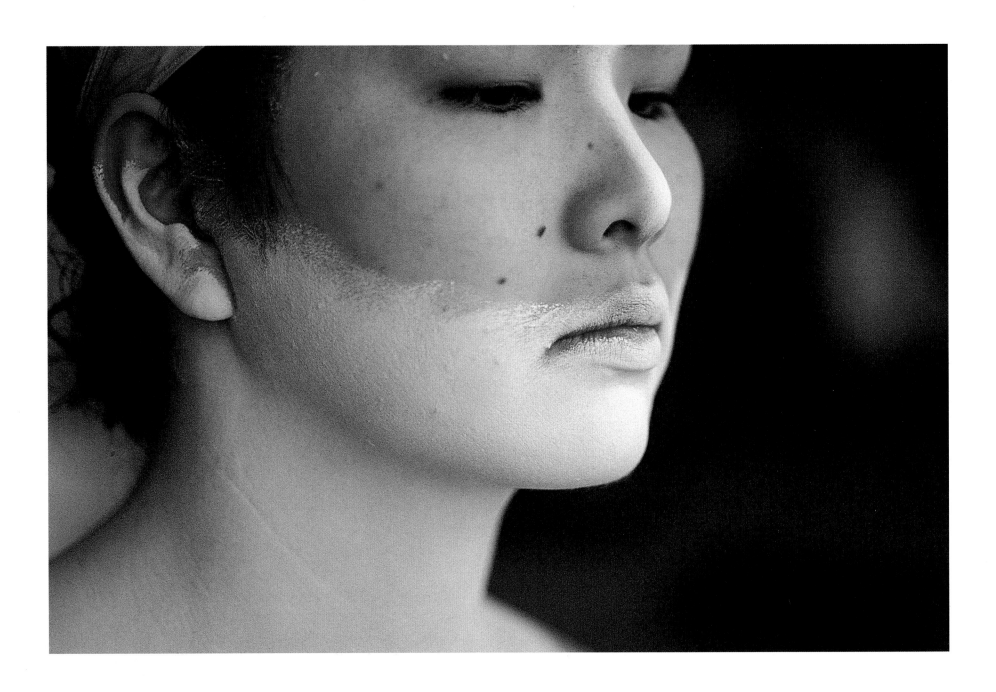

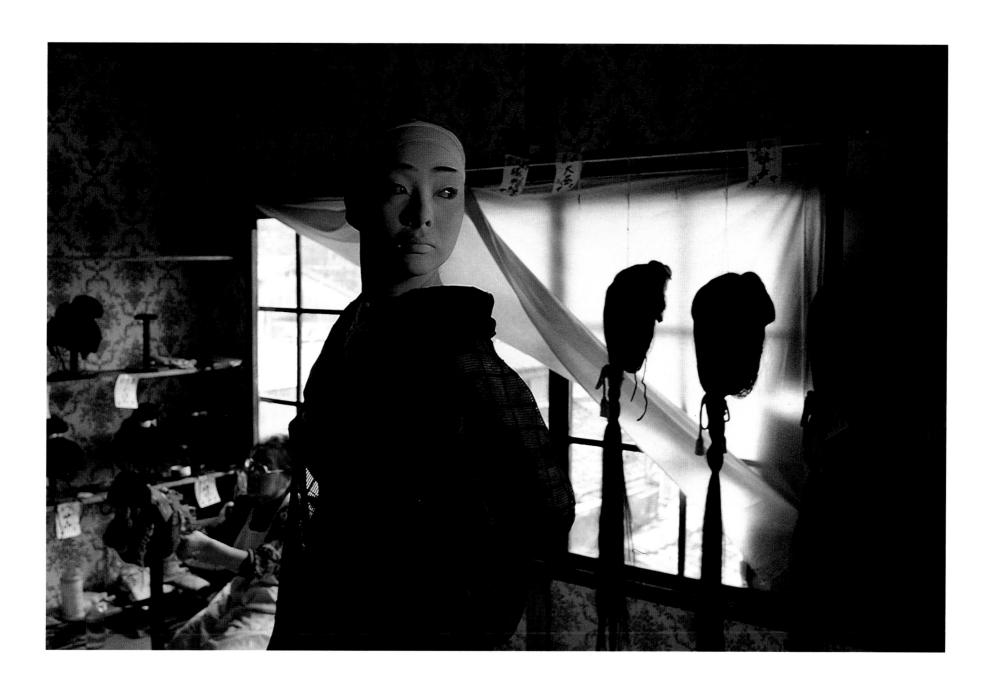

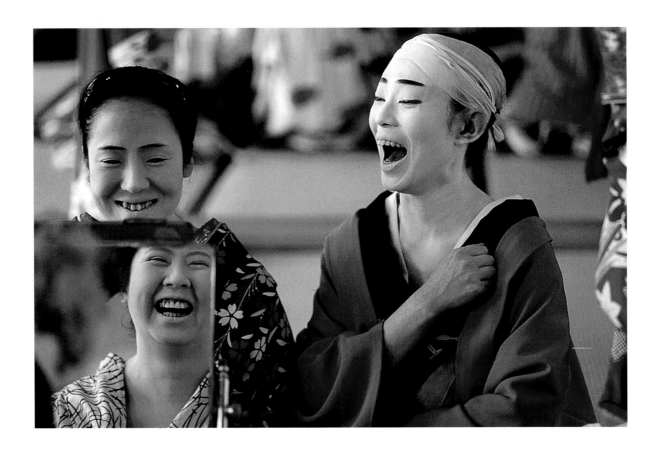

"Last night I had a client from the Meiji era [someone past eighty] who tried to touch my body! It was horrible! I tried

 to escape!"

"My date slipped down the stairs, fell flat on his face, and looked like he'd been flattened by a tractor. I now call him

 Tractor Uncle!"

—Backstage chatter

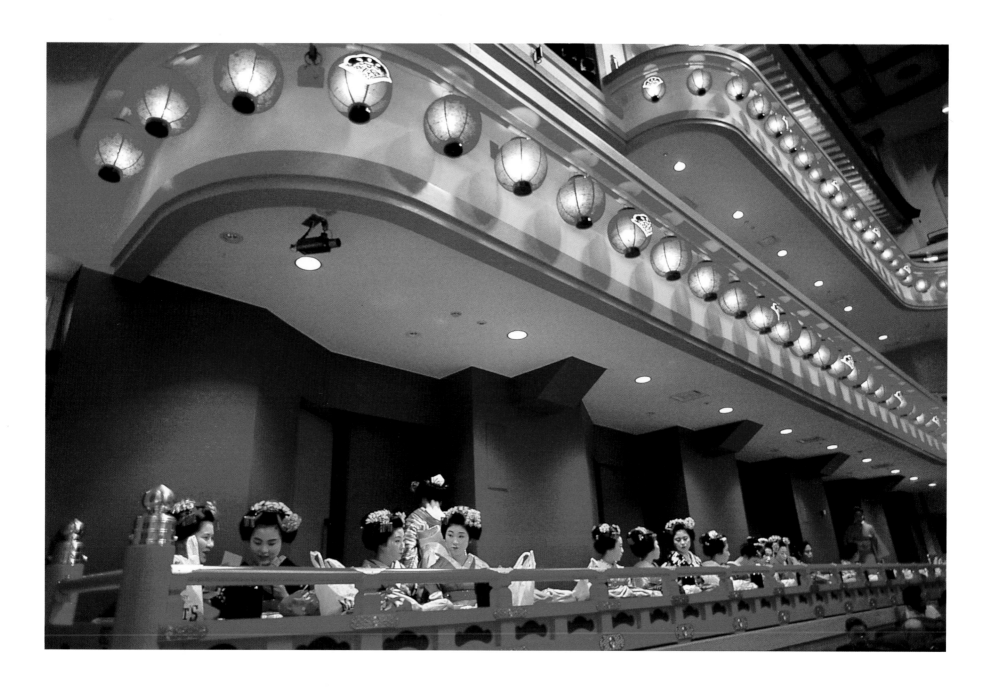

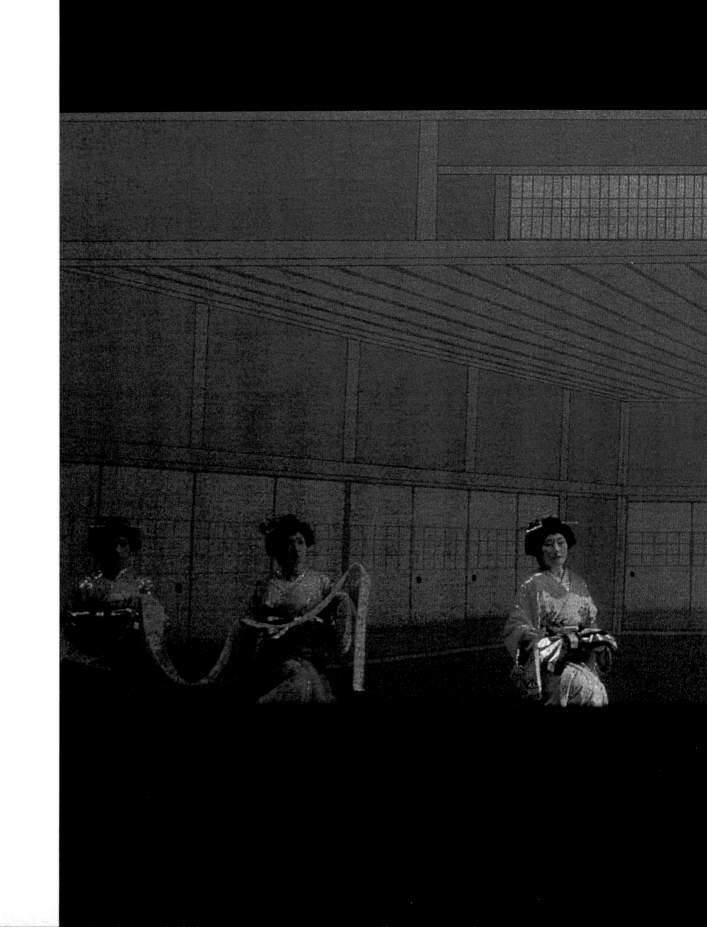

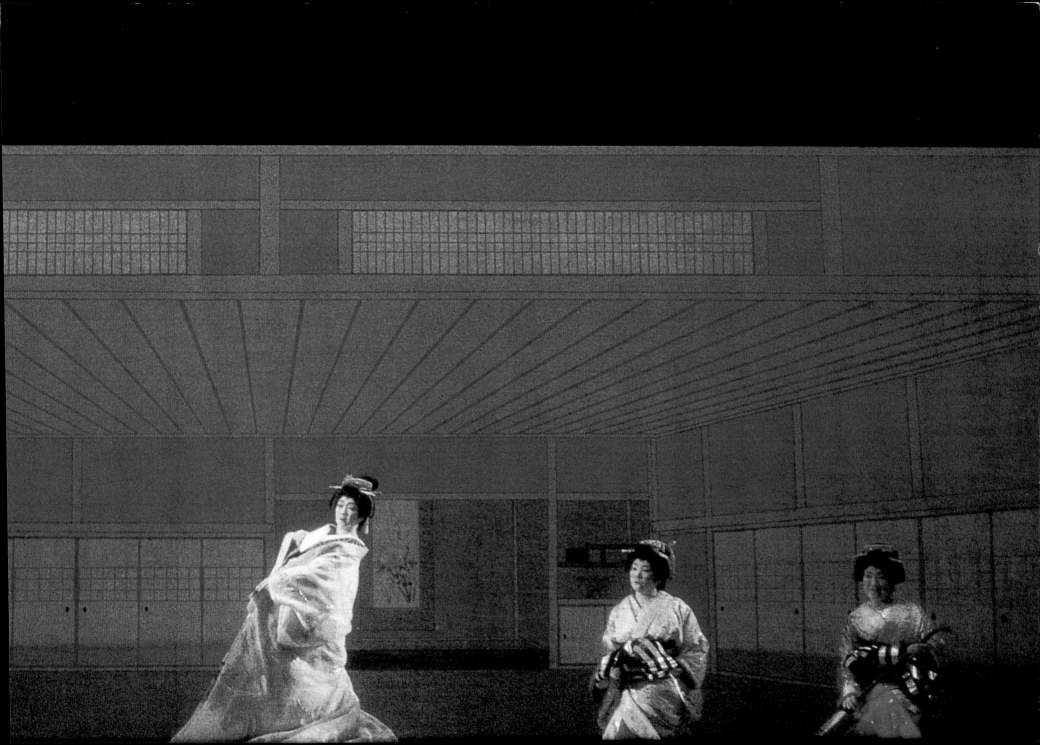

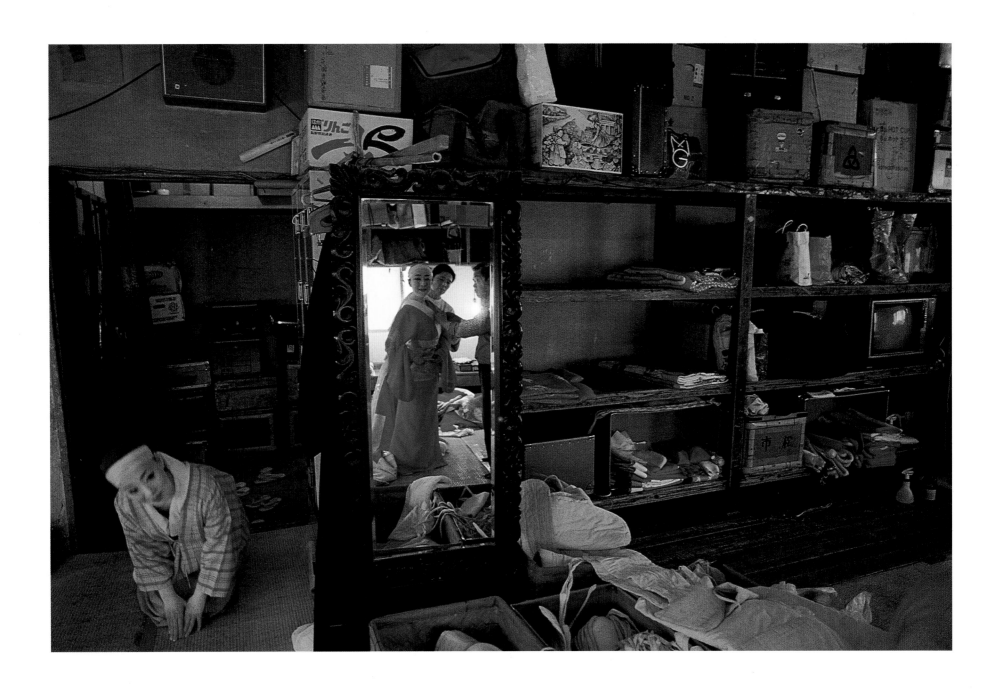

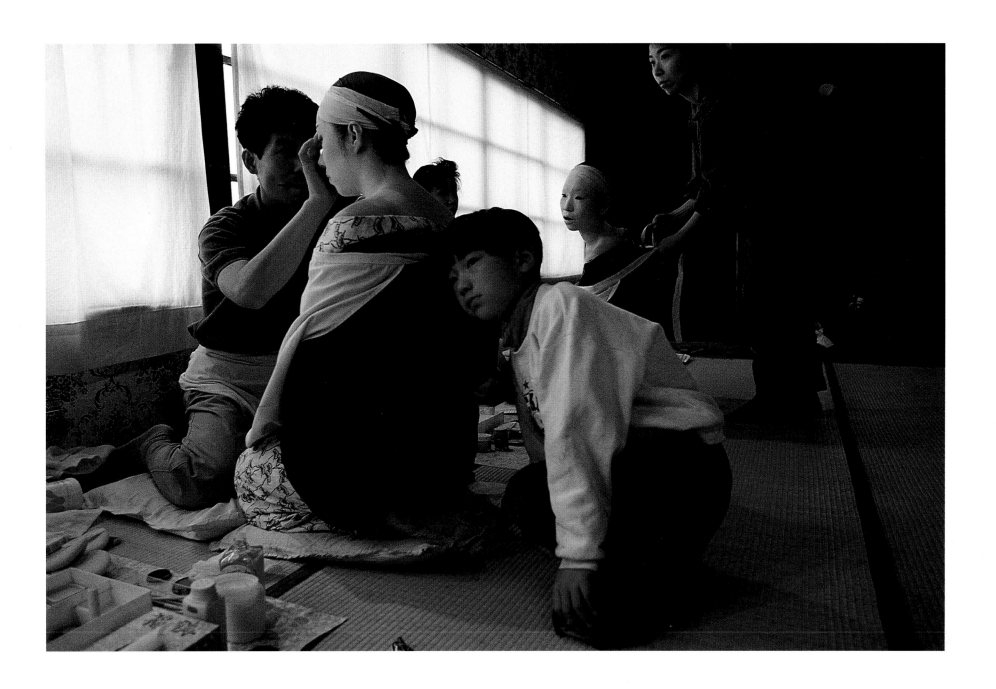

"Everyone wants to know how magic is created. The geisha world has such deep secrets and techniques—I could spend my whole life trying to find its core. After three or four hundred years of history, its secrets are still intact—and always will be.

"It is a dream, a dream come true. The heart of a man is the heart of Japan, and as long as the heart of Japan resides in the geisha world, both will survive."

—Kyoto client

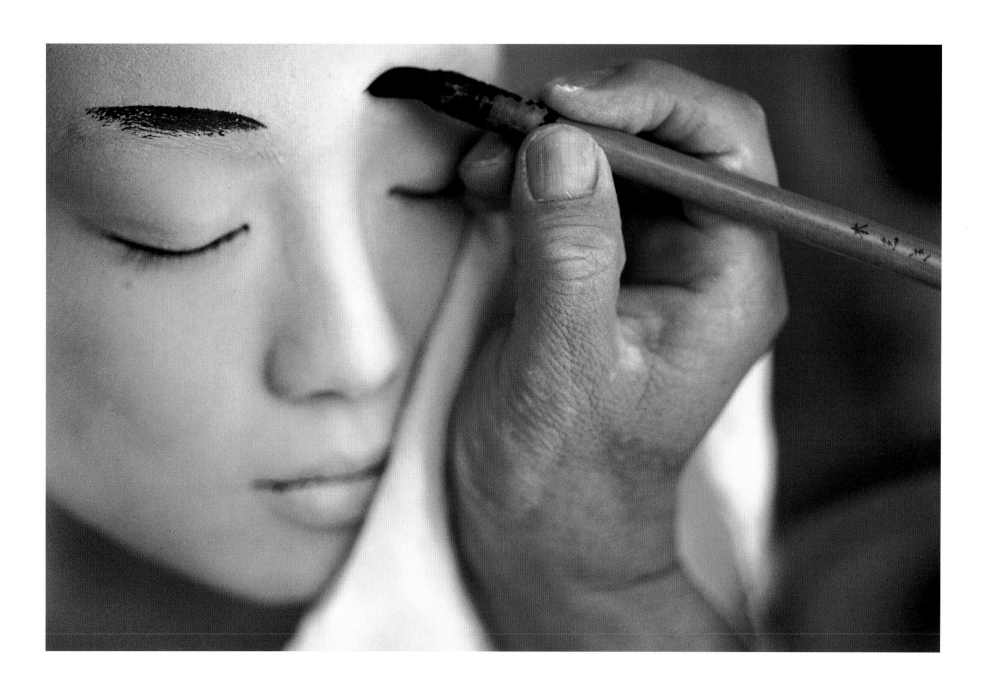

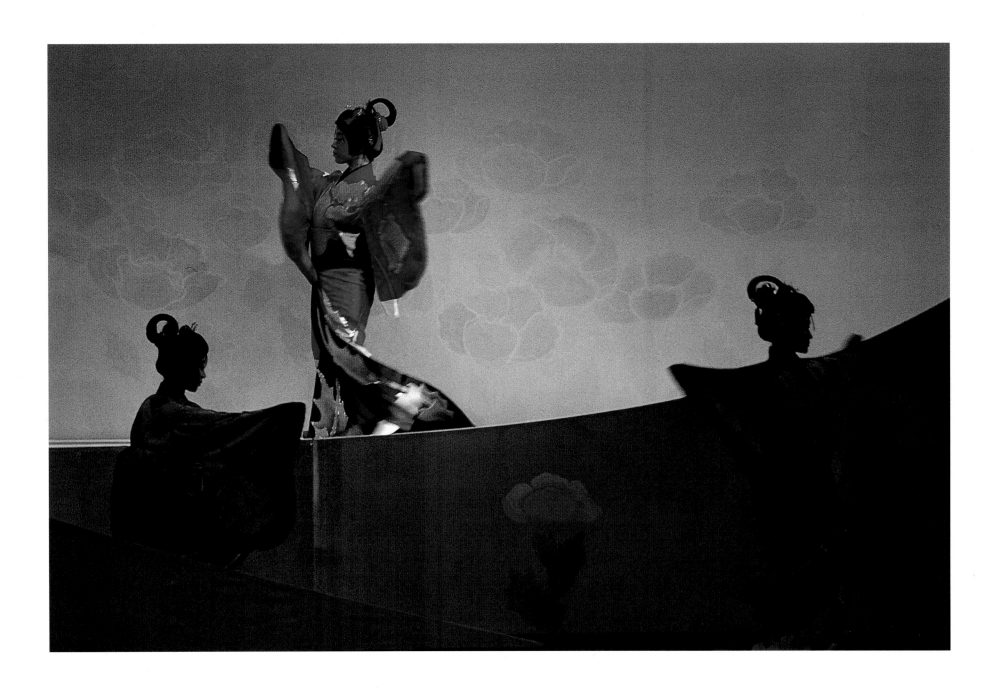

I know *she* is light and faithless,
But *she* has come back half-repentant
And very pale and very sad.
A butterfly needs somewhere to rest
At evening.

— GEISHA SONG

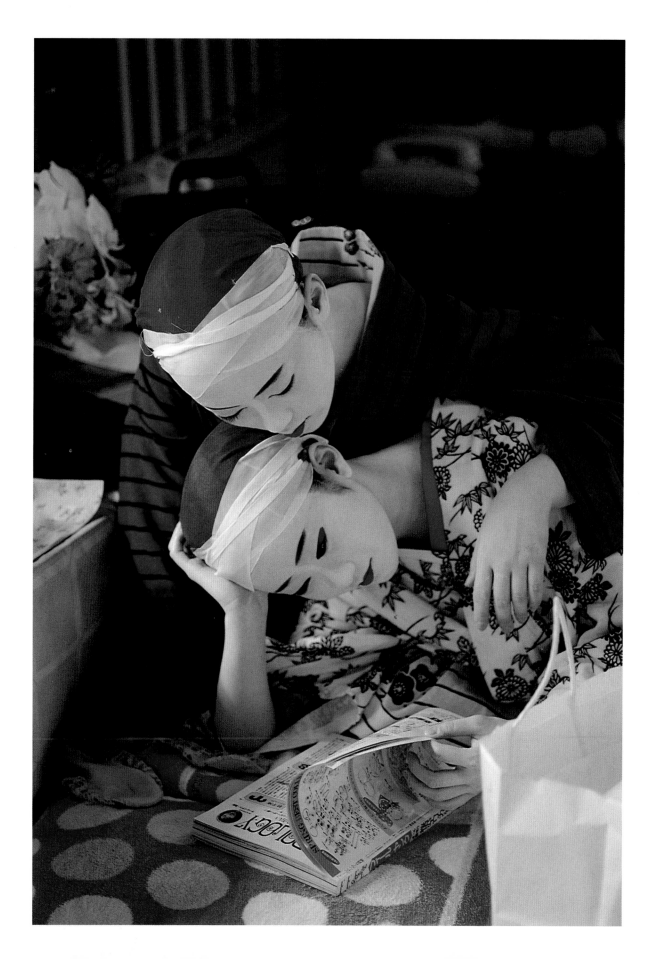

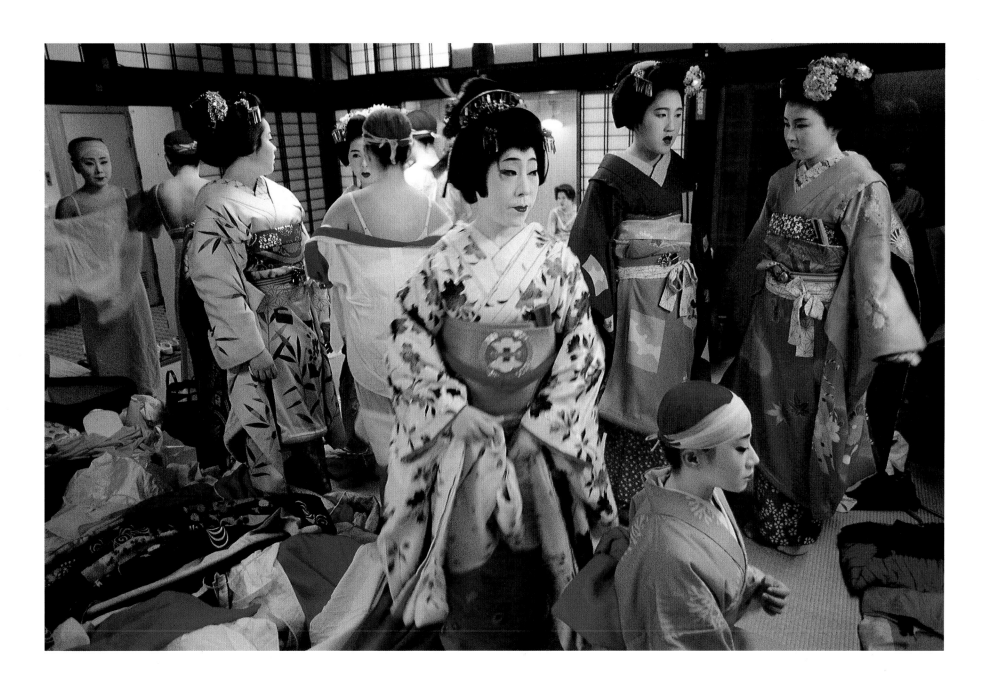

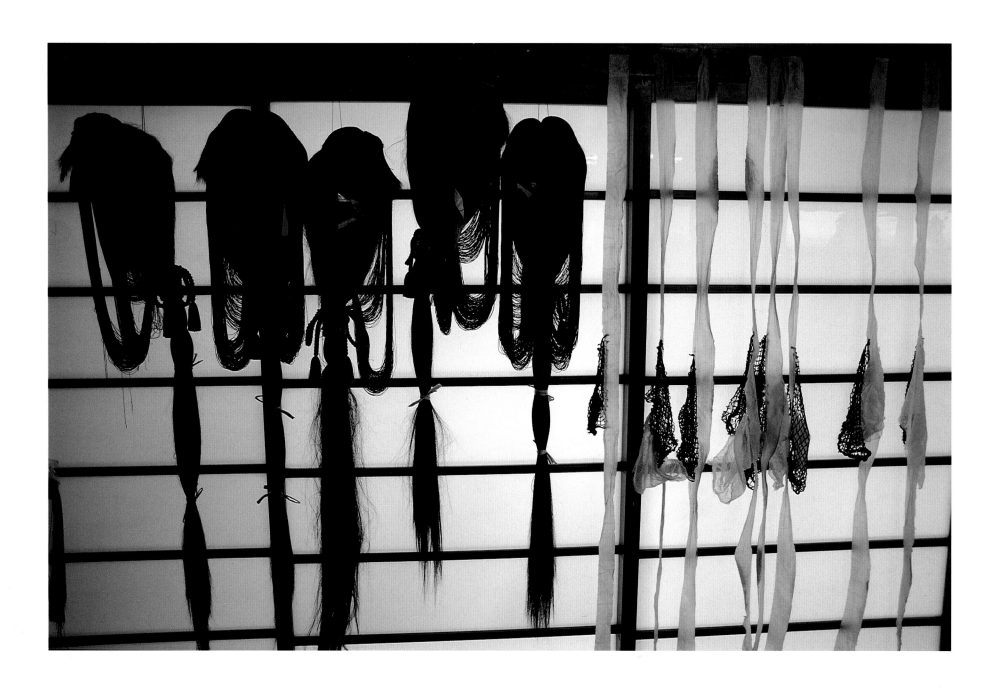

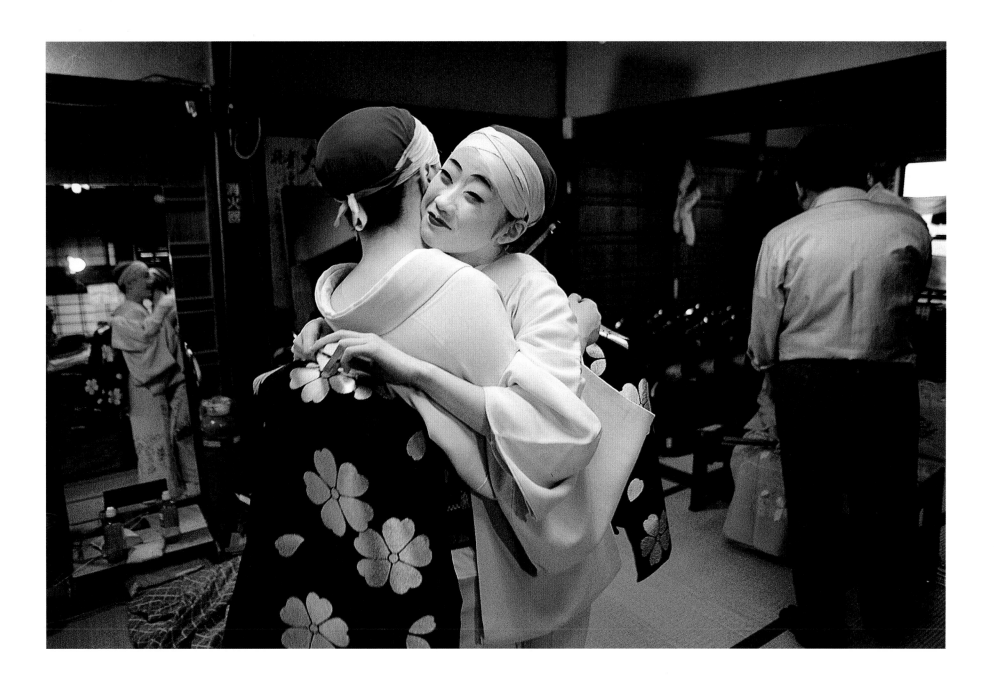

Longing, longing
To be together
I fret my days away.
Ever so once in a while
We steal a night together,
 and part
Longing, longing.

Parting is merely longing,
 never farewell—
The temple bell sounding
 at dawn.
—GEISHA SONG

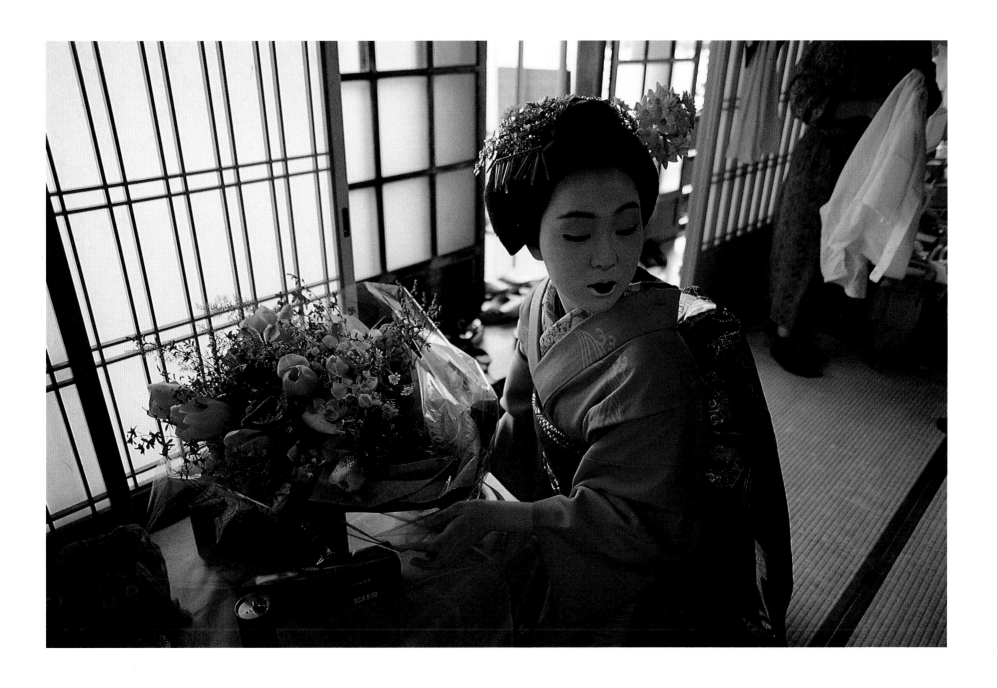

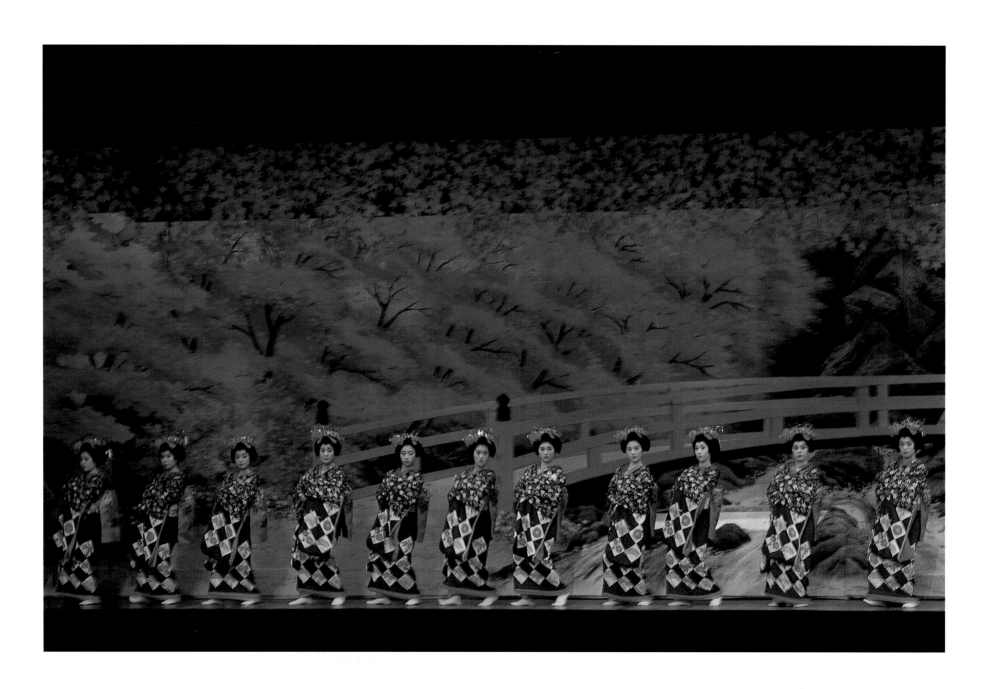

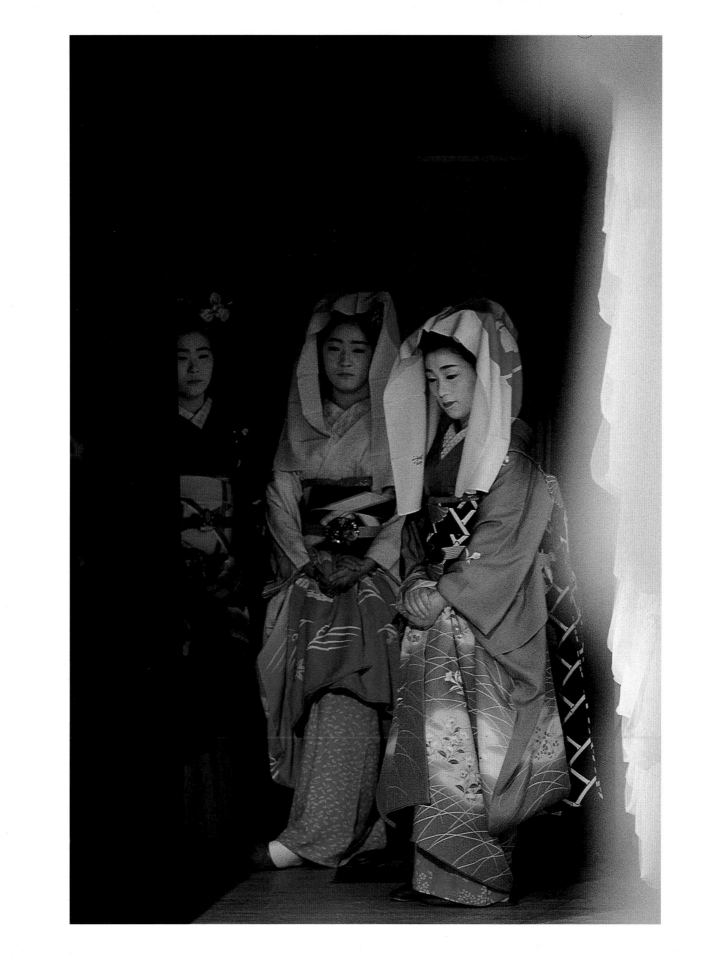

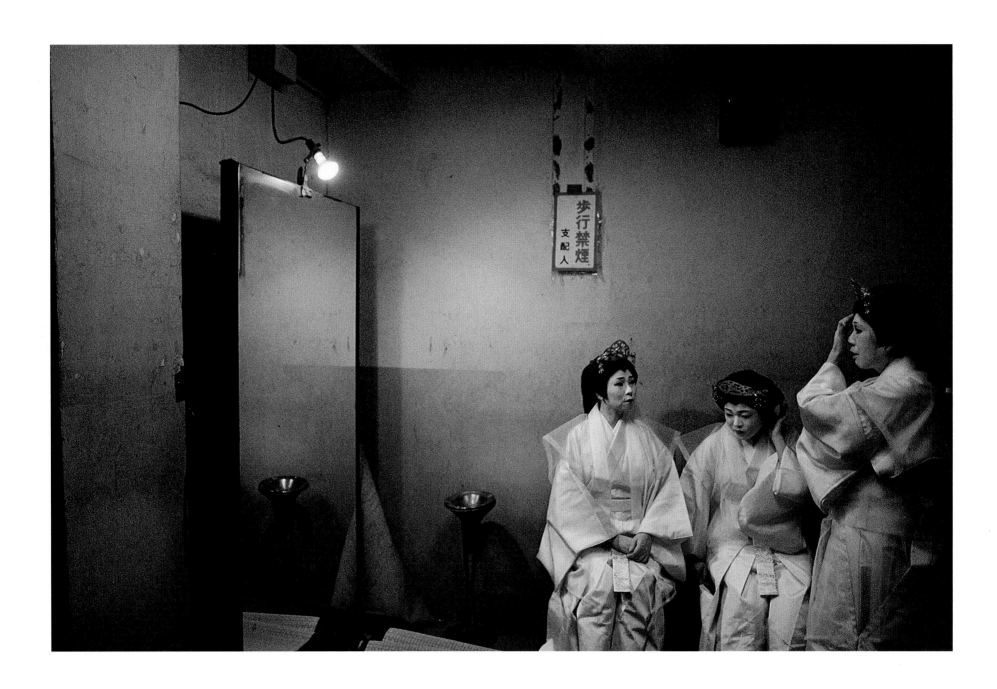

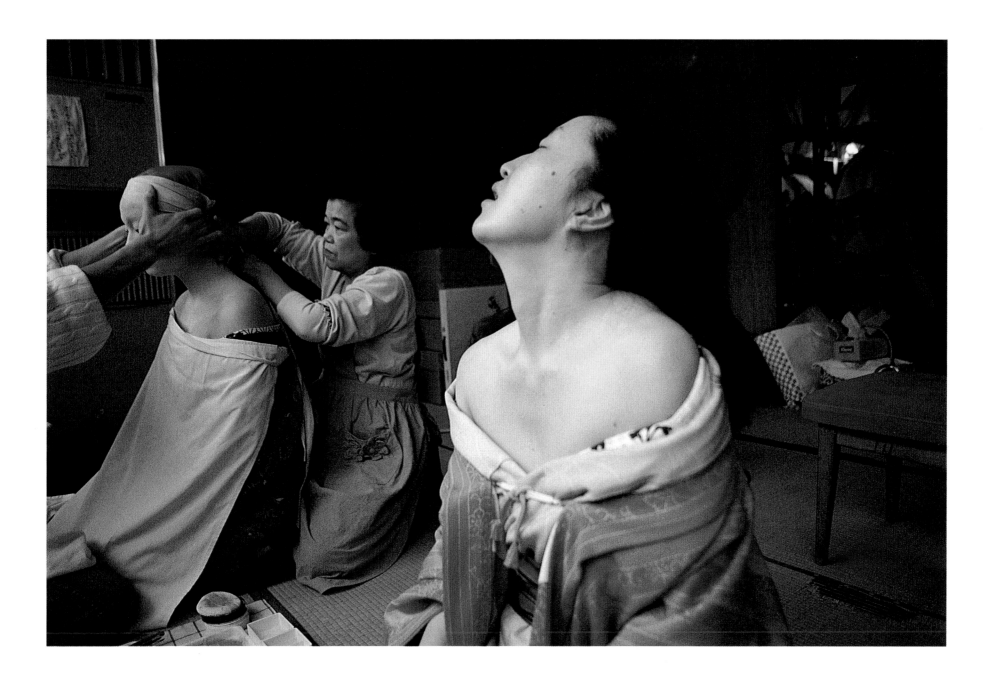

"This world is like Hollywood—the smart young girls concentrate on their skills; the dumb ones look for a man. As in *A Chorus Line,* everyone has something different she wants. But the serious ones stay. In the end, art is everything."

—Mayumi, geisha

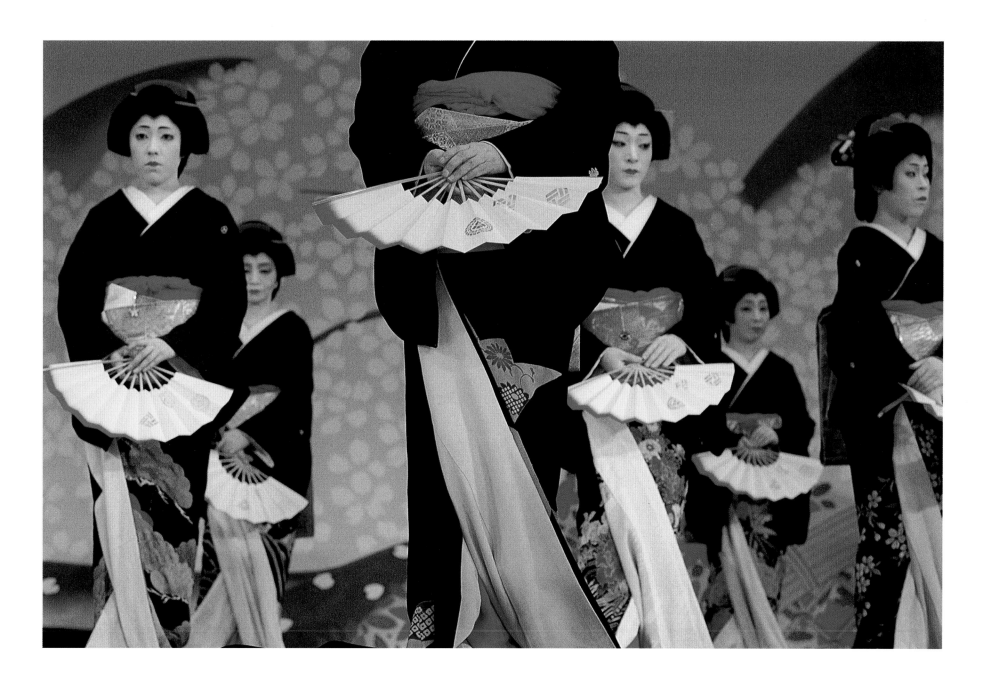

"Geisha will prepare three months for a dance that lasts two days. But people now want their pleasures fast. We must learn the difference between making things efficient and preserving our culture. Clients think they can appreciate these traditional arts just because they're Japanese. But in fact they have forgotten.

"Geisha are a cultural possession of a city and a barometer of its vitality—it would be a real loss not to have them. But in thirty years there will be just a few old ladies left. They are too locked into old ways. It is tradition destroying tradition."

—Dance master

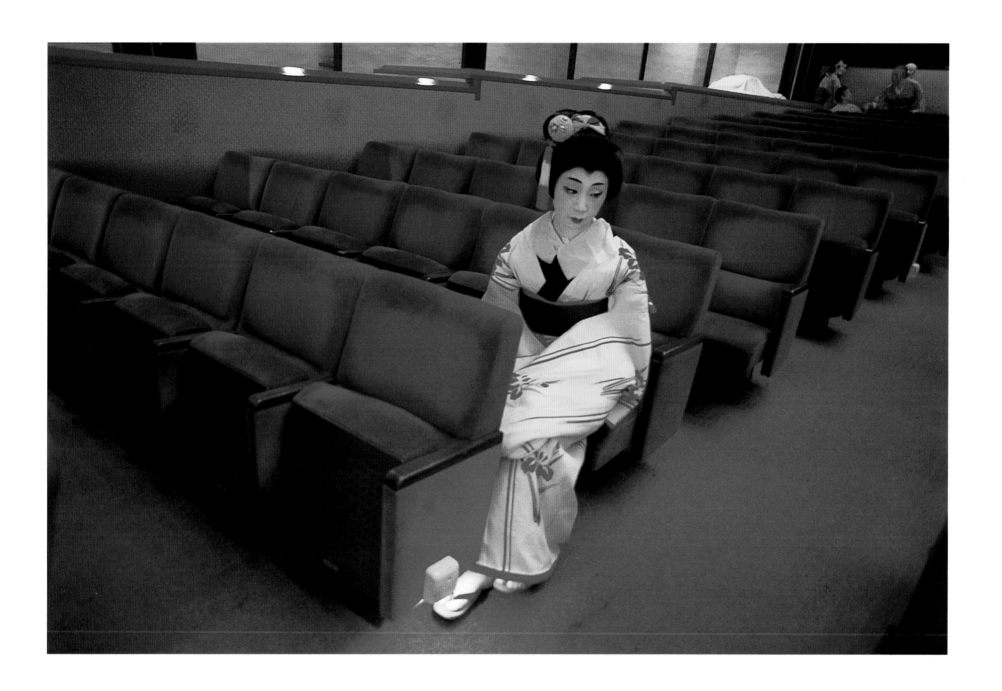

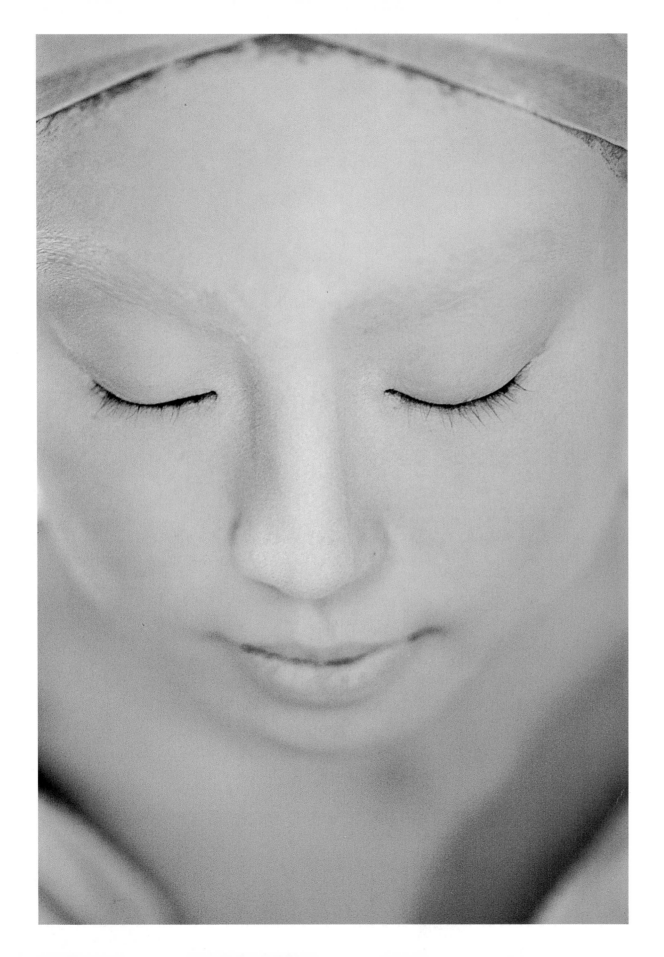

When I see the first new moon
Faintly in the dusk
I think of the moth eyebrows
Of a girl I saw only once.

—ANONYMOUS POEM

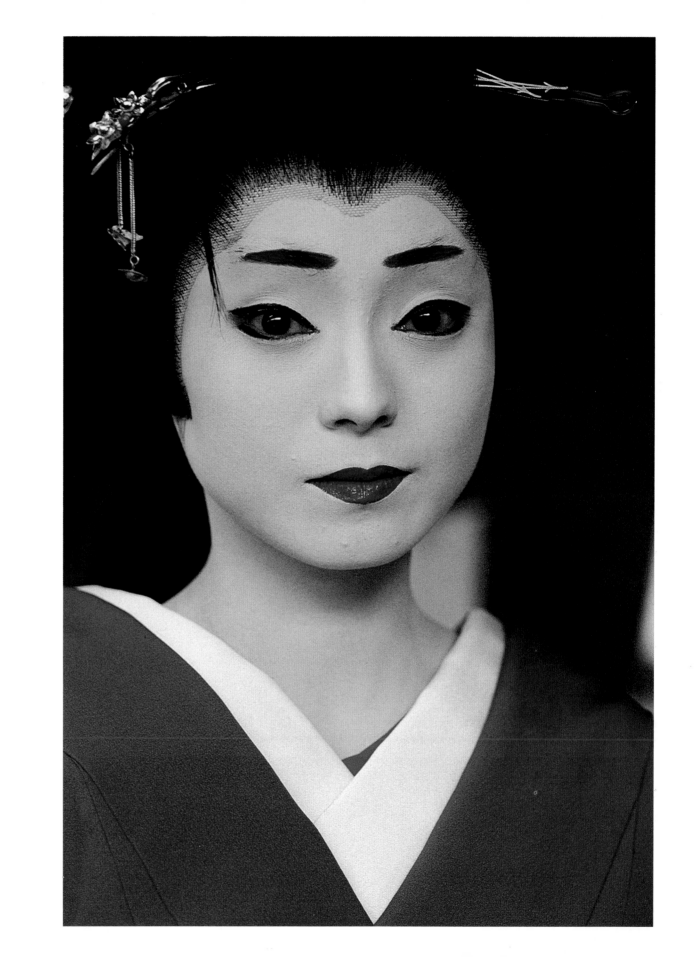

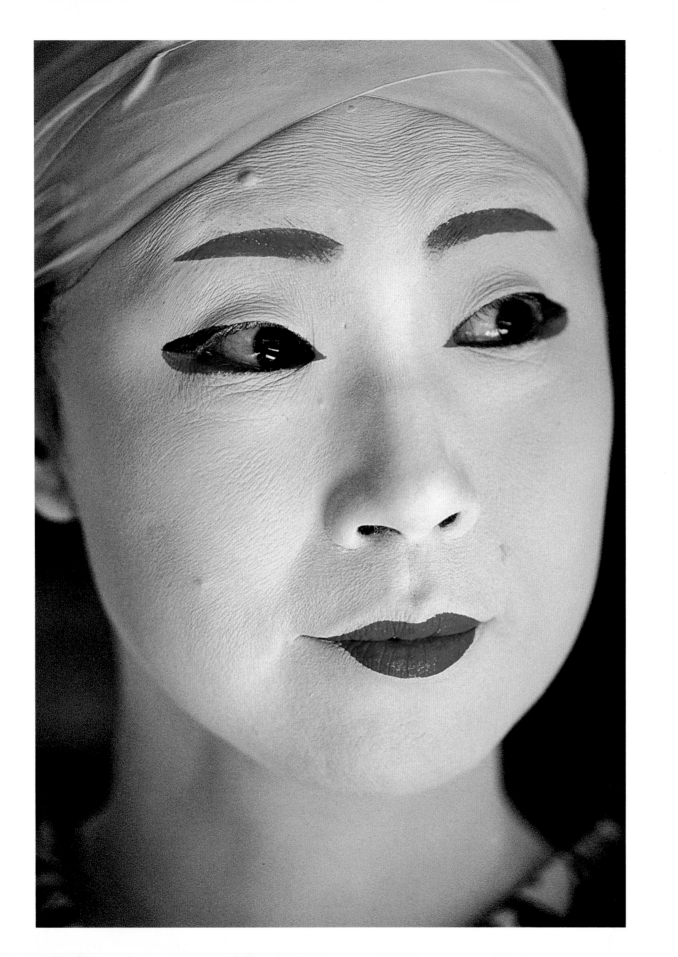

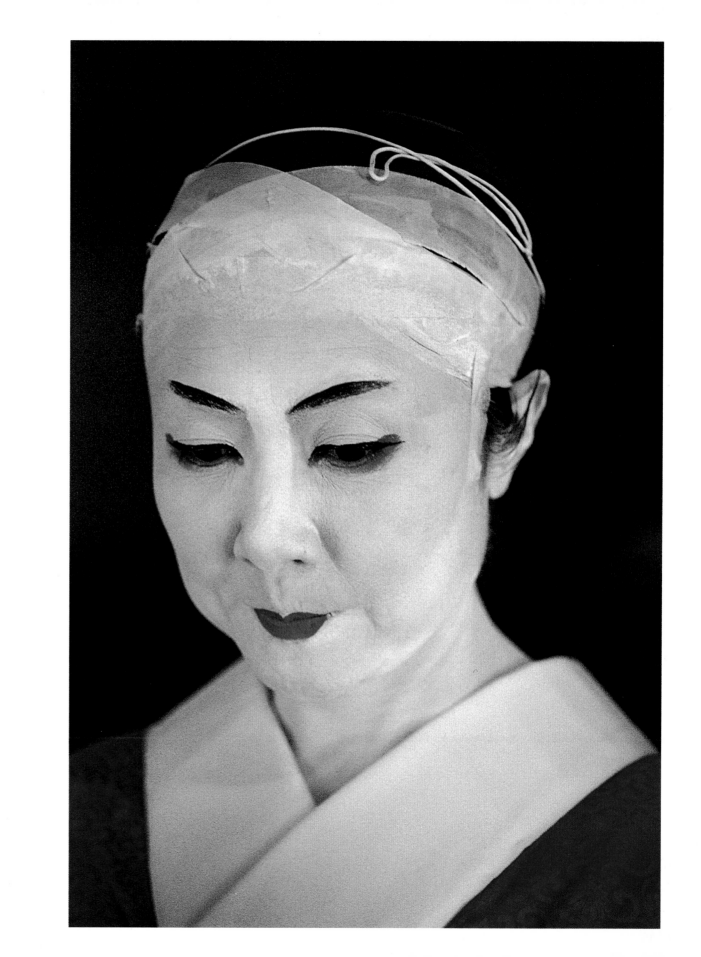

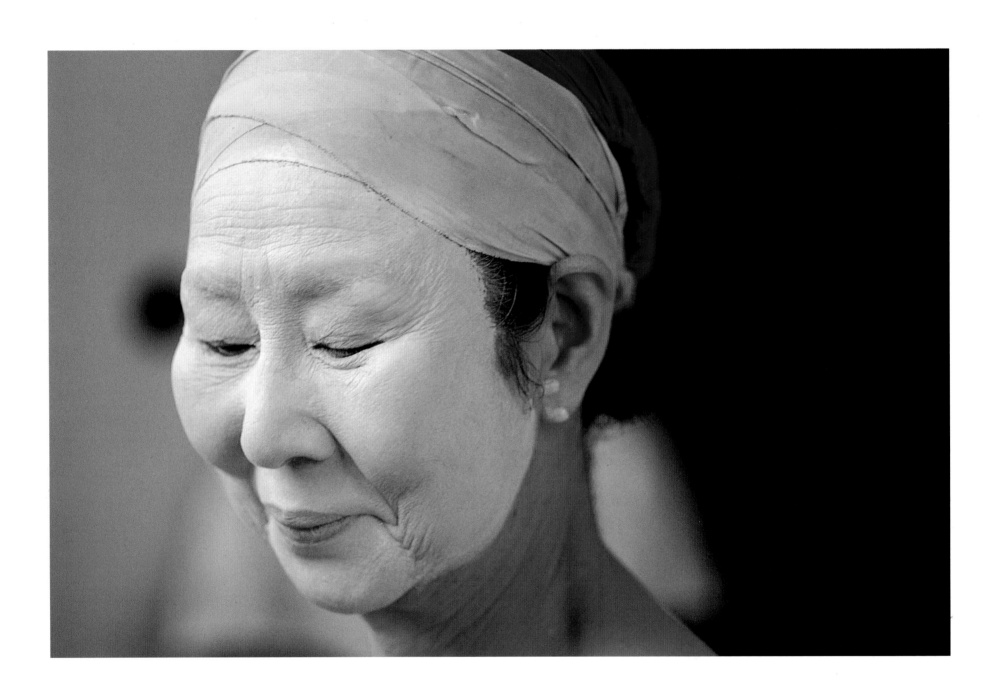

"This is just my business face, not the real me. A geisha on the outside may look very pretty, but inside can be a different story. This world is too difficult for human relationships—you must forget yourself and your true feelings. The elder geisha have built armor around themselves that will never break open. The sad choice of a geisha's life is whether to be a wonderful person in the flower and willow world or a wonderful person in real life."

—Tokyo geisha

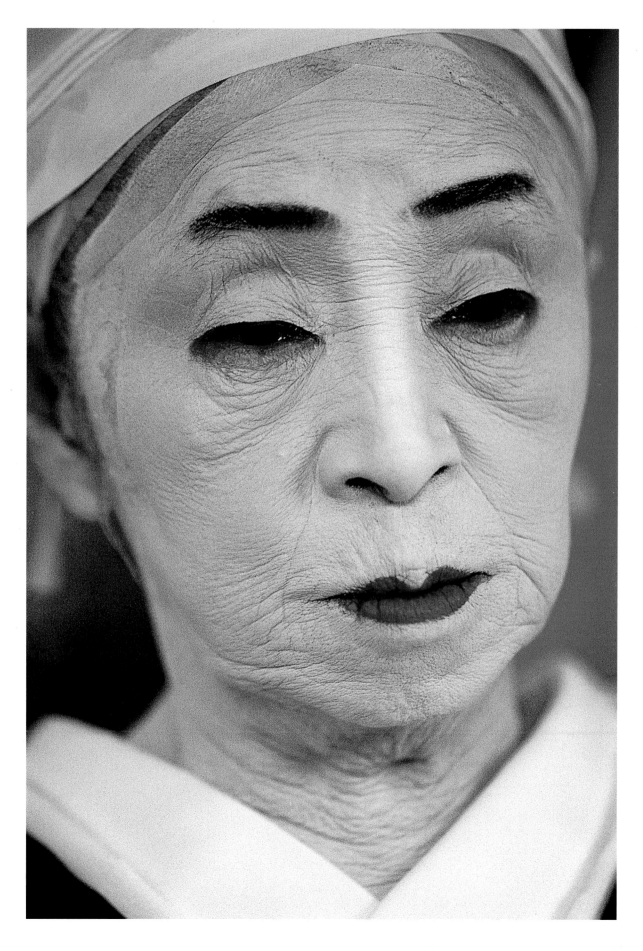

INSIDE
THE "PLEASURE
QUARTERS"

"An *obi* is like a man's necktie. You tie it tight, and you become upright and rigid. I'm like a businessman putting on his suit in the morning, preparing for his daily battle, forgetting his personal life. When I put on makeup and a kimono, I turn into a geisha in my mind also. It happens naturally. In a kimono, I am a professional."

—Tokyo geisha

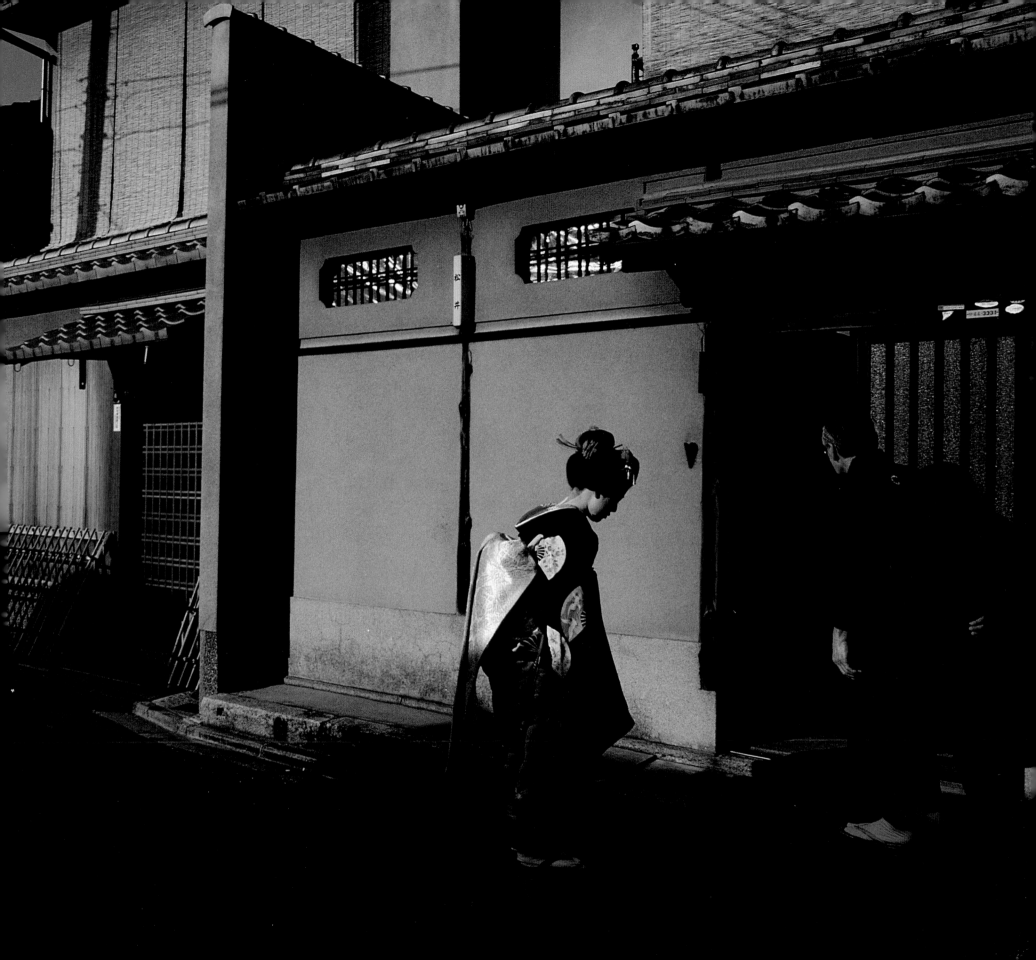

"High praise in the geisha world is the expression *komata no kereagatta hito.* It originally described the beautiful shape of the hairline on the back of the neck. But because we put the makeup on our necks to mirror the shape of the genital area, it now means a geisha with a lovely genital area, a 'beautifully lined place,' who has also developed her *gei* to a high degree. It is the perfect combination of erotic beauty and high artistic achievement. It is what we aspire to."

—Geisha

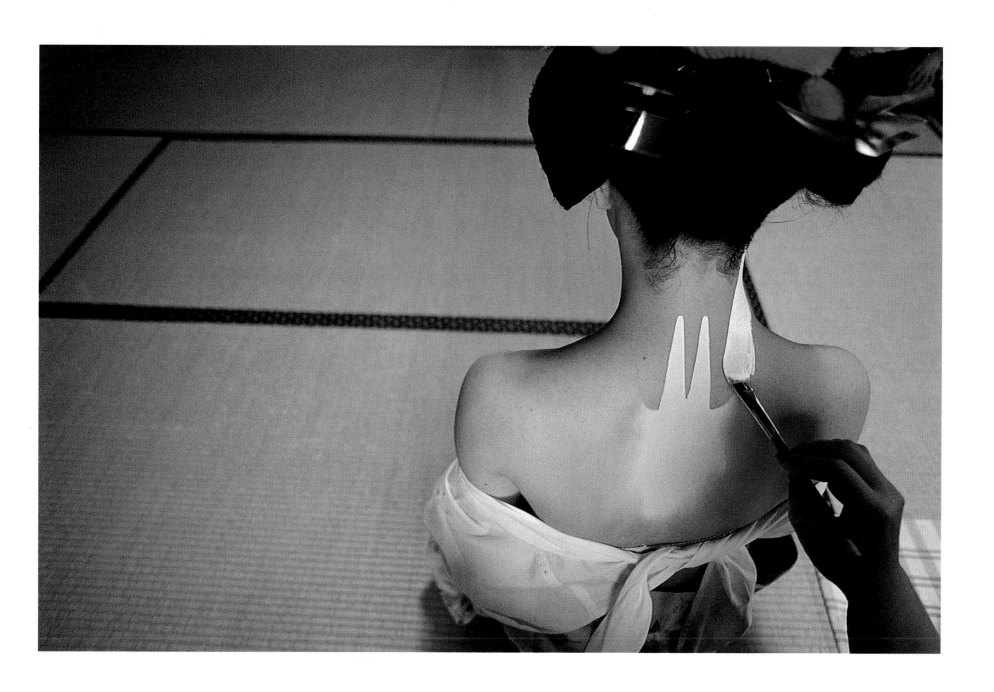

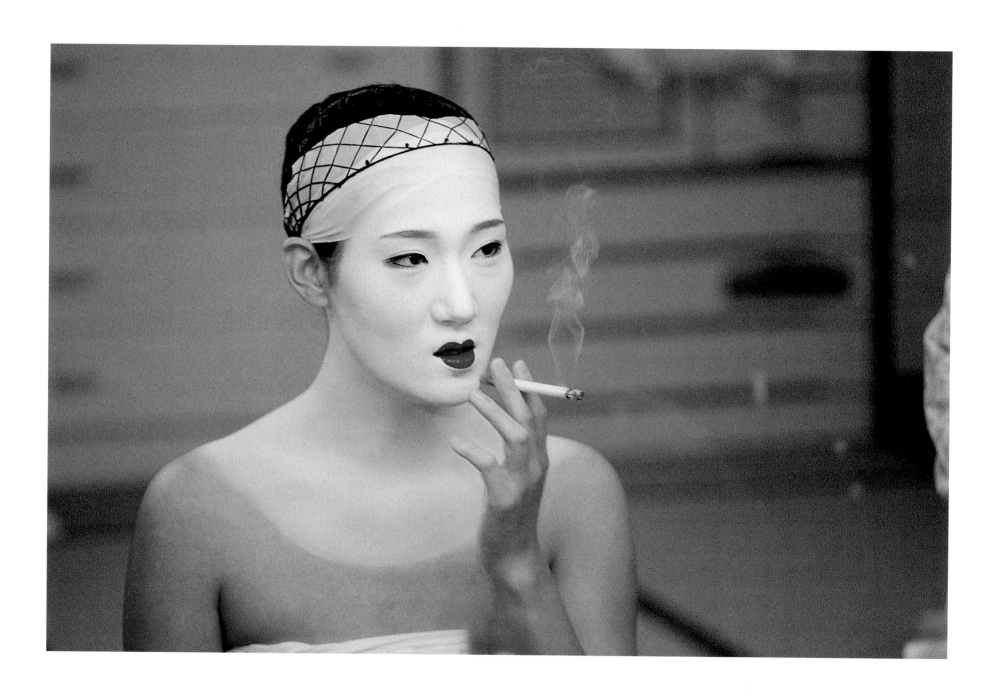

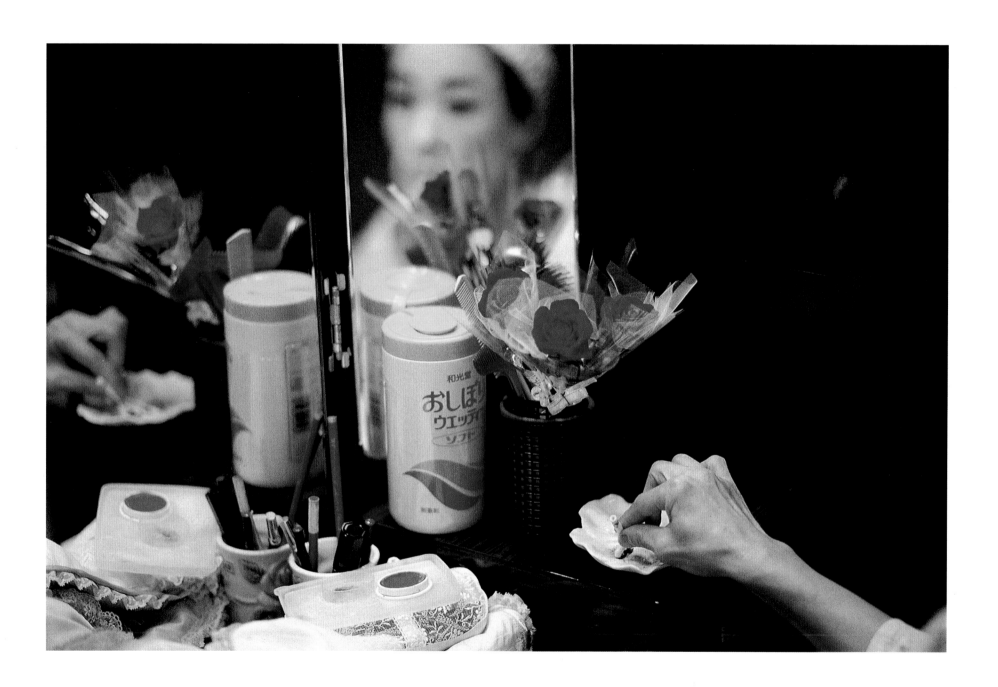

THE FIVE HEARTS—GEISHA HOUSE MOTTO

1. A gentle and obedient heart—to have the heart to say "Yes"

2. An apologetic heart—to say "I'm sorry," and admit and reflect on mistakes

3. A modest heart—to give credit to others for any accomplishments

4. A volunteer heart—to say "I will do it" without thought of benefit

5. An appreciative heart—to say "Thank you."

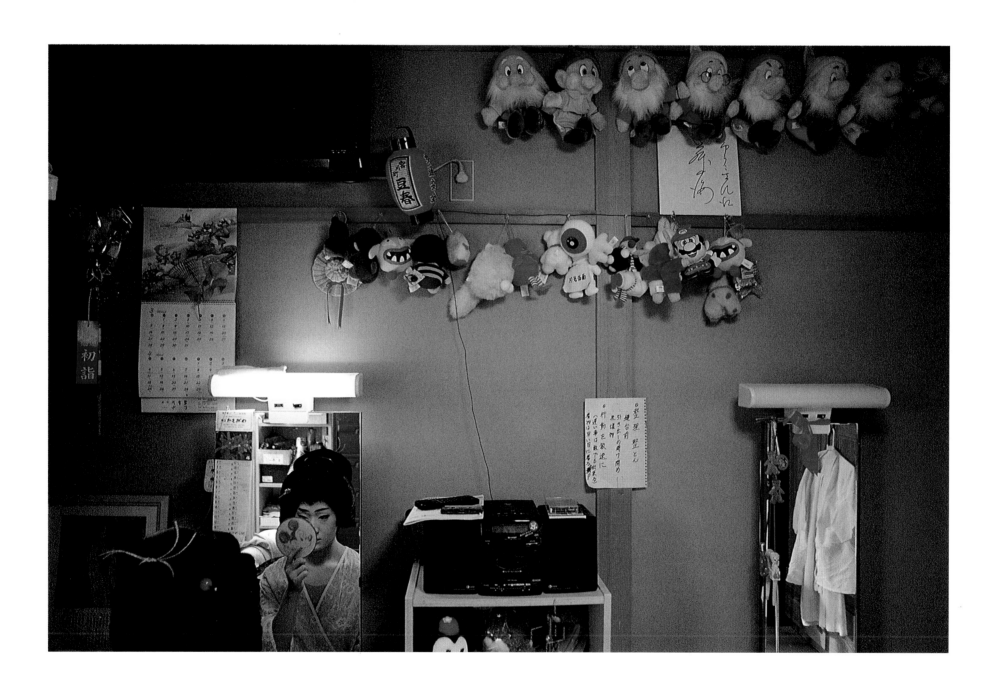

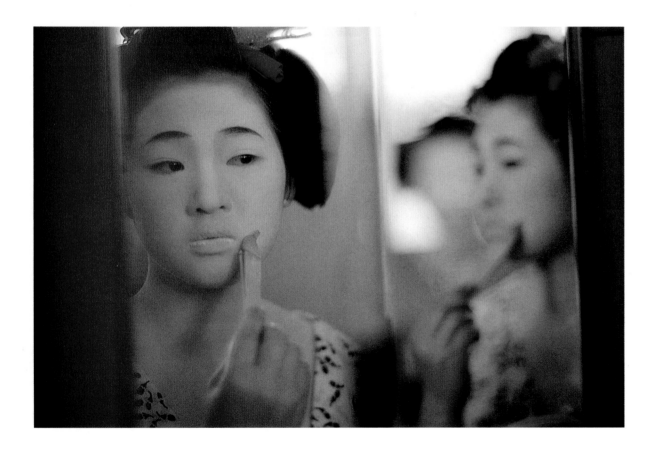

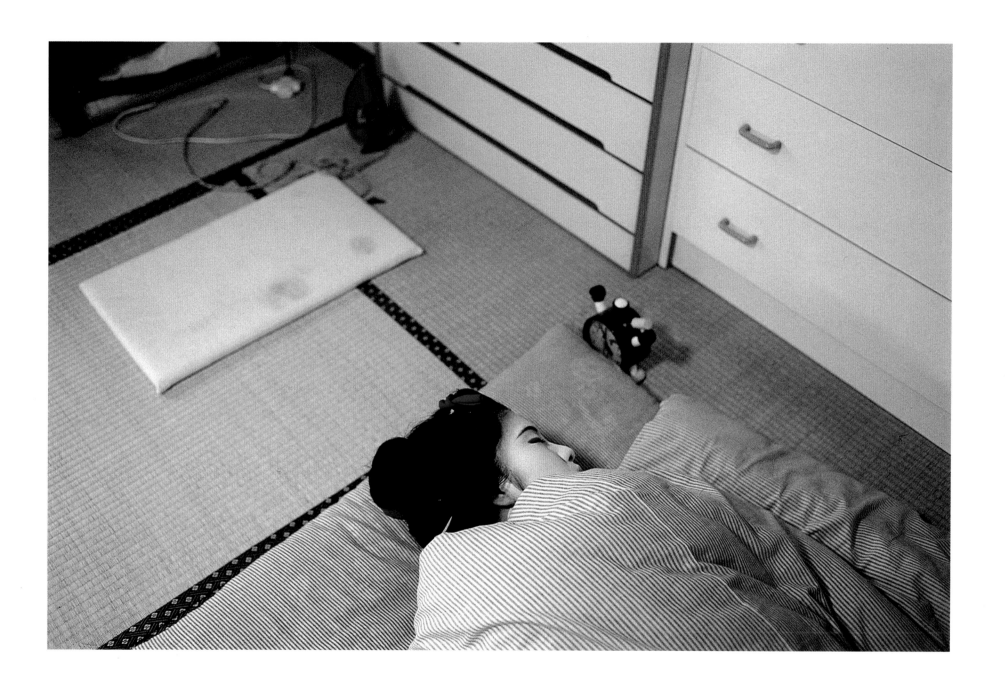

"My secret dream is to become a Buddhist nun. I want meaning in my life. I'm tired of people's eyes. Someone is always looking at me—even when I'm in a taxi, heads turn, people stop and stare, surprise on their faces. I'm tired of pretending to be someone I'm not, tired of flattery. To be a nun would not be that different from a geisha—both worlds require long training periods to strain out your own desires, to reach beyond the life of a normal person. I would love to be thought of as a frank and honest person, speaking and acting as I really feel. But this business won't allow that."

—Kyoto geisha

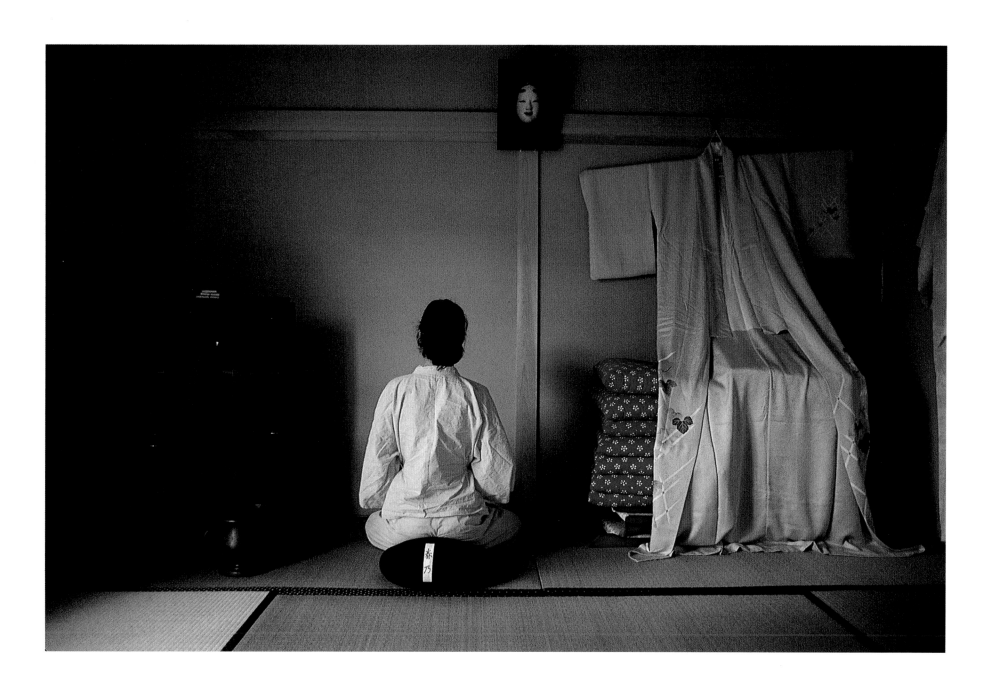

I bathed my snow skin
In pure Tamagava River.
Our quarrel is loosened slowly,
And he loosens my hair.
I am all uncombed.
I will not remember him,
I will not altogether forget him,
I will wait for spring.

—GEISHA SONG

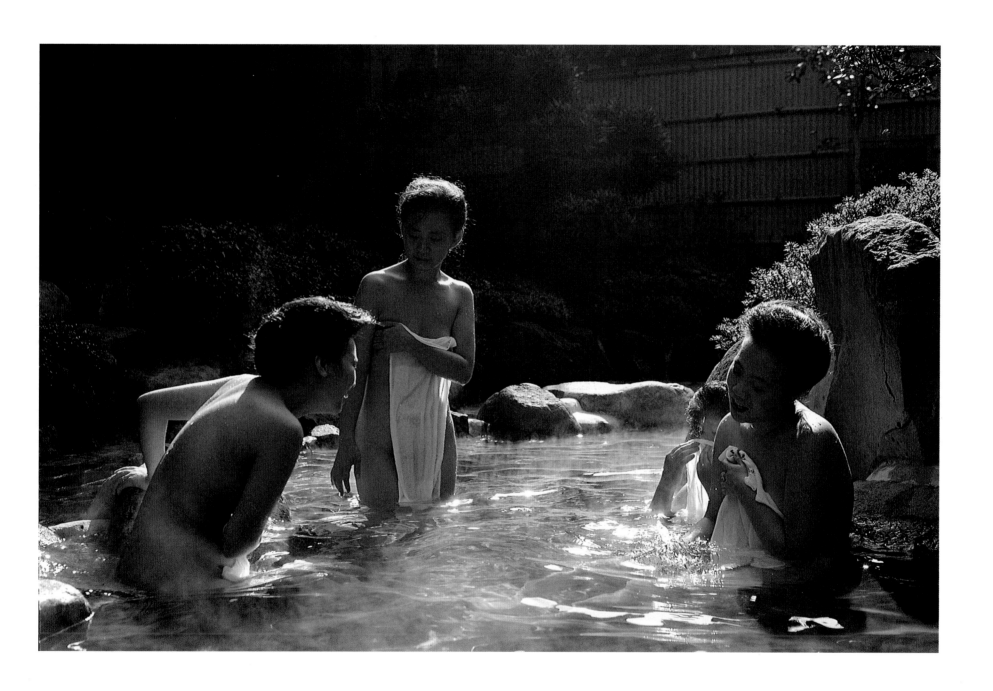

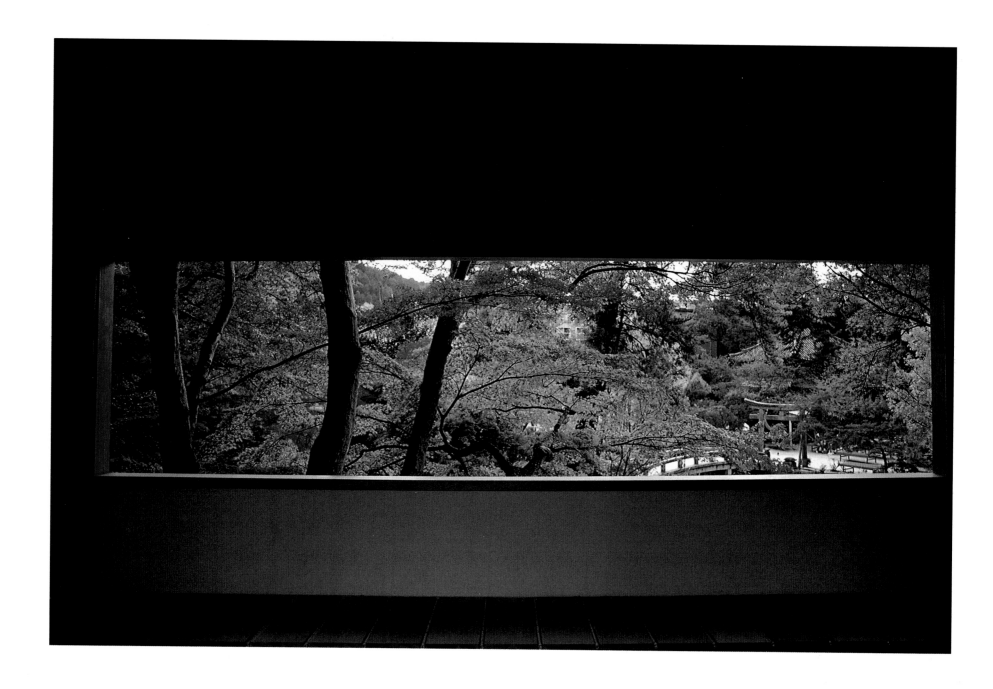

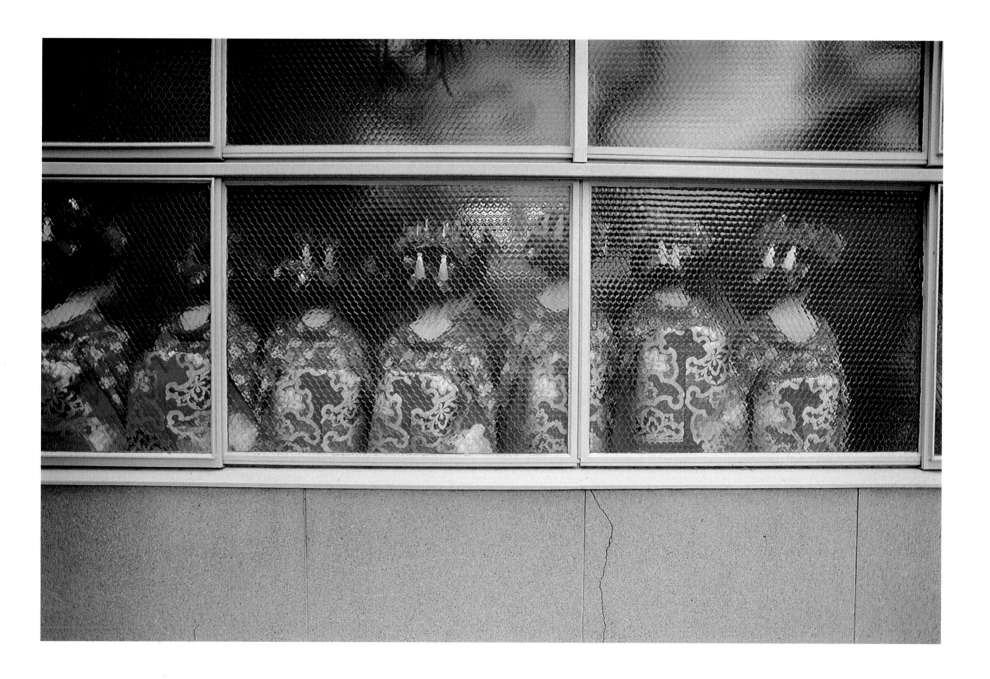

"Red is erotic. The red underkimono symbolizes the change from girl to woman, and we carefully show a trace at the collar and hem. The men find it quite sexy. They love the nape of the neck, the ankle and of course the genital area—but not large breasts. Small ones look better in a kimono. We never bound our feet like the Chinese, but men find the sight of a foot in *tabi* very sensual.

"*Mizu-age* used to be a *maiko*'s first sexual experience, when she changed from a girl to a woman, and she then changed the color of her underkimono from white to red. It was a ceremonial event, decided by the *okamisan* of a geisha house who picked a favorite client, and cost ten million yen. Because she was only eleven or twelve, a virgin and very nervous, it was set up to cause the girl the least embarrassment. By the pillow, they would exchange sake cups as a ritual. The kimono was put on so that a single pull would undo the *obi*. Total nudity was considered crass—that idea only came in with the West—so all she had to do was allow access. The *mizu-age* ritual was forbidden by the anti-prostitution law of 1958, but before that it was decided by the elders, and had to be performed."

—Kyoto geisha

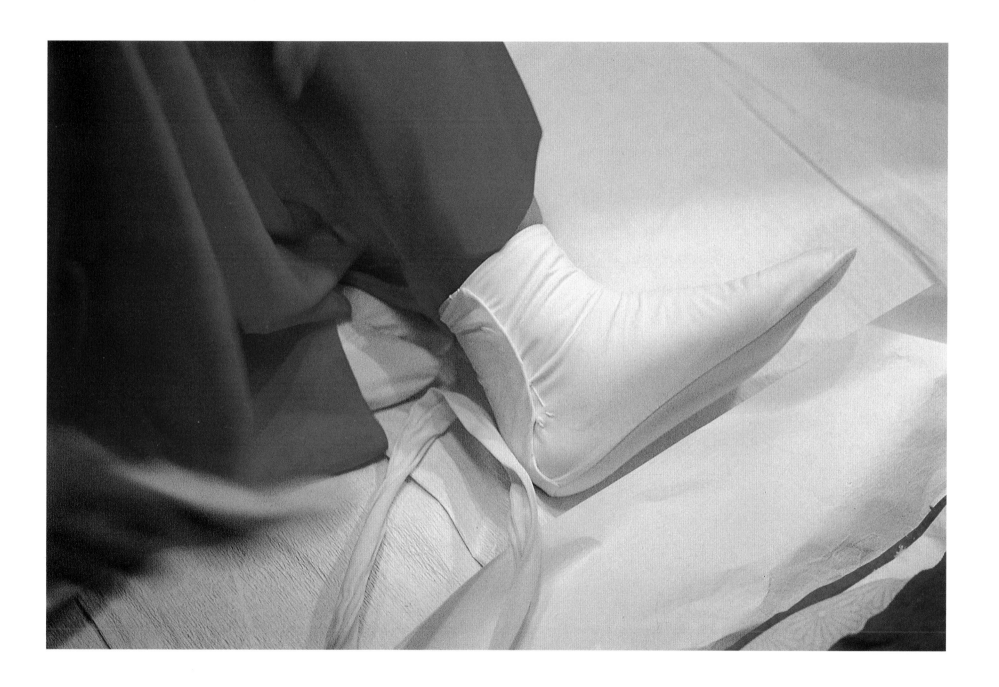

"It's hard to live in a geisha house. There are too many of us in one place, and things get out of control. This world is too competitive, and filled with jealousies. I have superficial friends, not real ones, and other geisha talk behind my back. But I believe in myself. When I was young, everything was new and I loved it all. But it's no longer a dream; it's all too real."

—Kyoto geisha

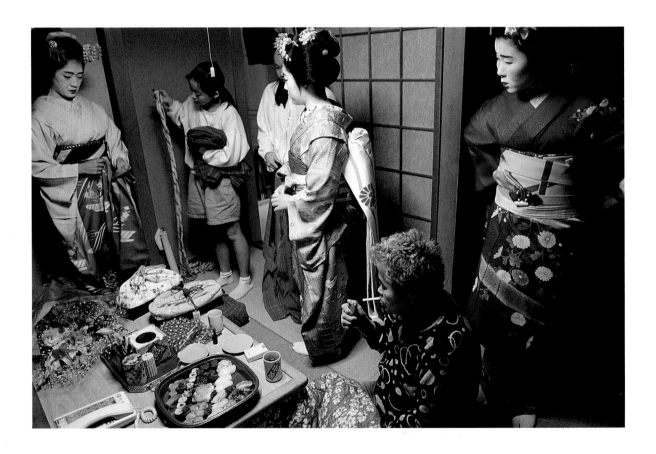

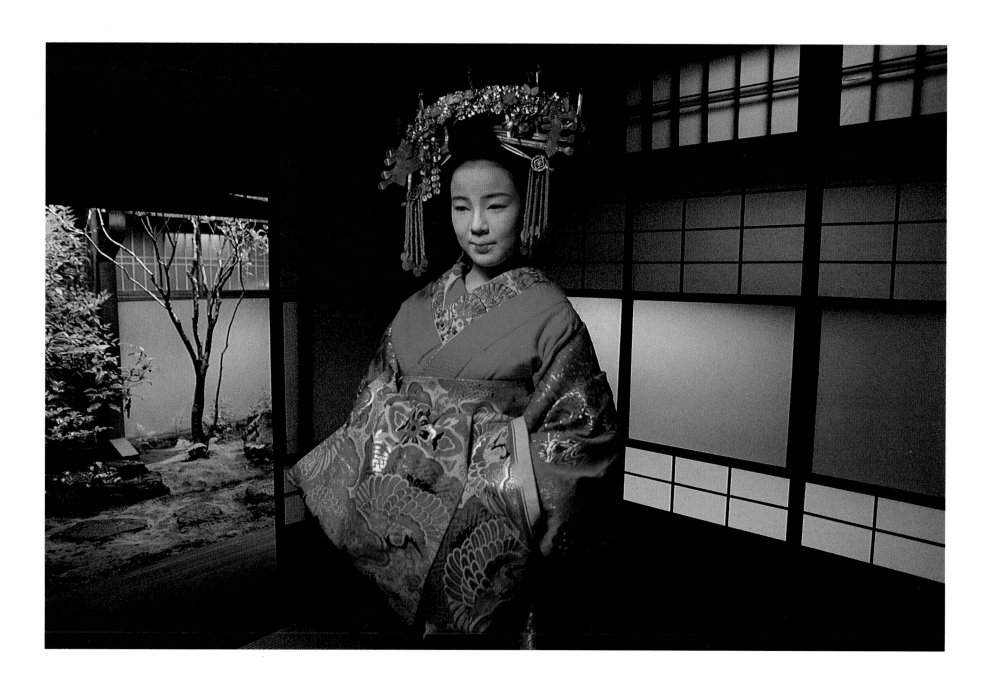

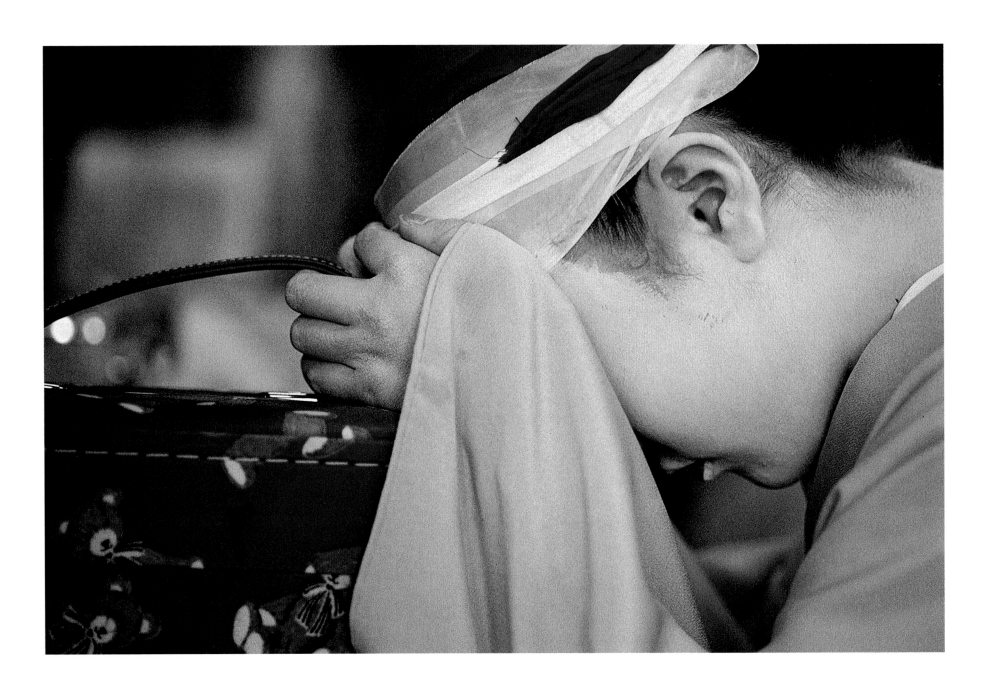

Waiting anxiously for you,
Unable to sleep, but falling into a doze—
Are those words of love
Floating to my pillow,
Or is this too a dream. . . .
My eyes open and here is my tear-drenched sleeve.
Perhaps it was a sudden rain.

— GEISHA SONG

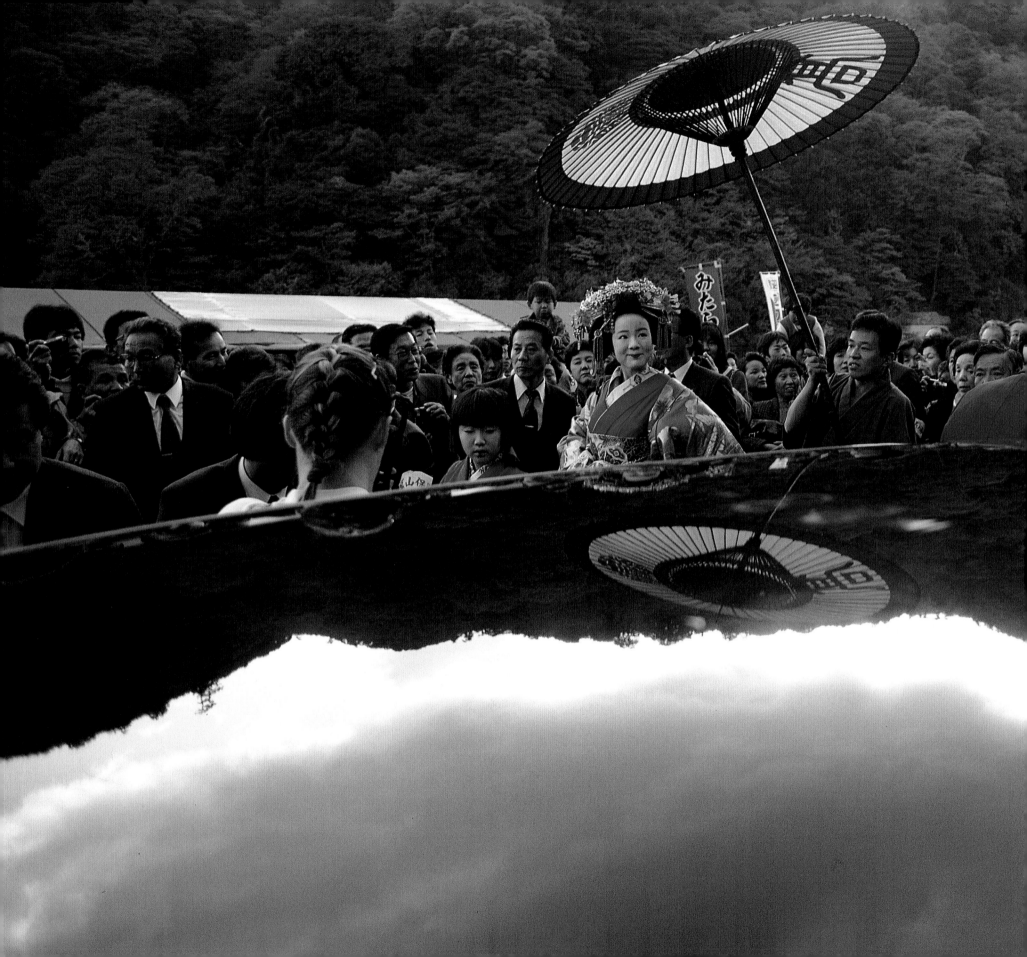

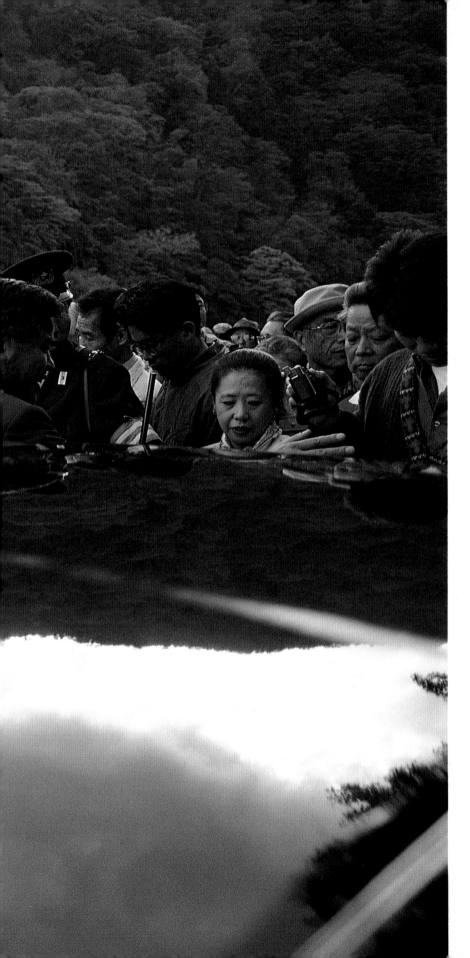

"When I became a geisha forty years ago, I was a hungry spirit—so poor I had nothing but desires. This world was more strict then, a completely vertical structure: heaven and hell. I was surrounded by women who were nasty and mean but disguised it well. It was not physical discipline, but meanness inherited through the generations, revenge for the way they had been treated. But I would rather they had hit me than what they did. It was like being strangled, but gradually, and with padding so the marks wouldn't show. The women I hated then I hate still, and even now I get nervous when I meet them. If young girls today had that kind of training, they wouldn't last one day, they would surely run away."

—Geisha house *okamisan*

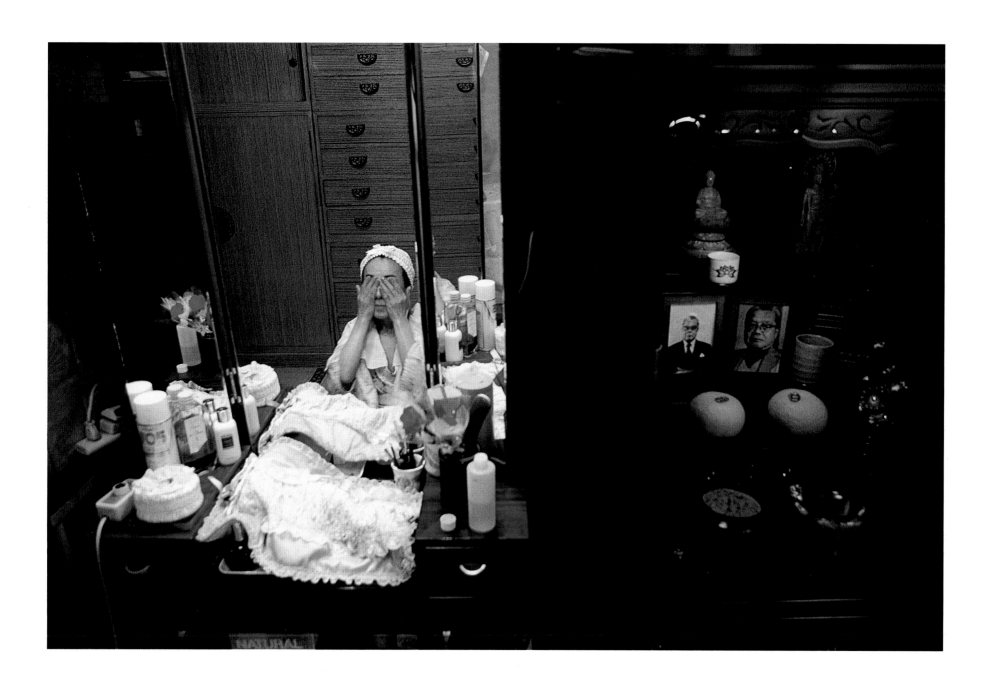

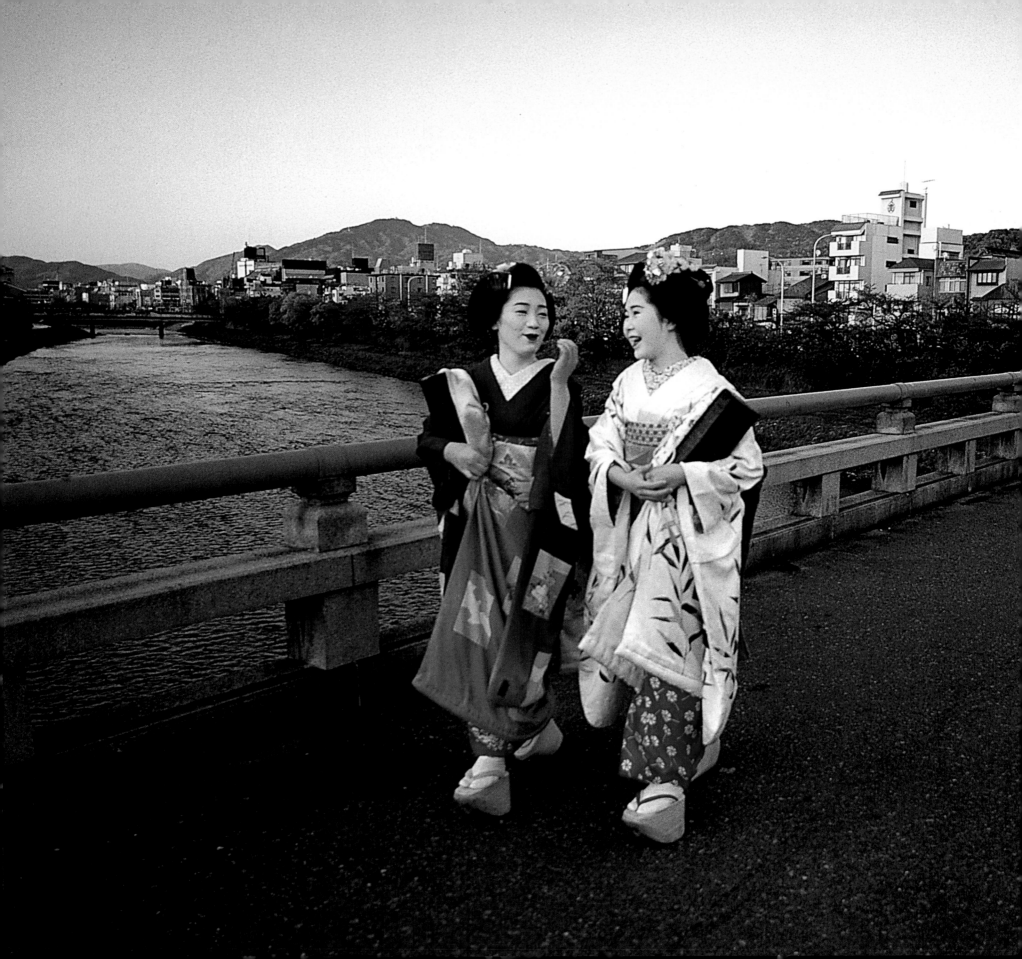

SELLING DREAMS

"It is a game we all agree to play. The geisha knows it is a game, and the client knows it is a game. We are buying and selling dreams. Clients come here to forget their daily life. So we don't say anything that is not part of their dream. We drink, and if the client wants us to dance, we dance, and if he wants us to sing, we sing. And we speak of things that have nothing to do with wives."

—Tokyo geisha

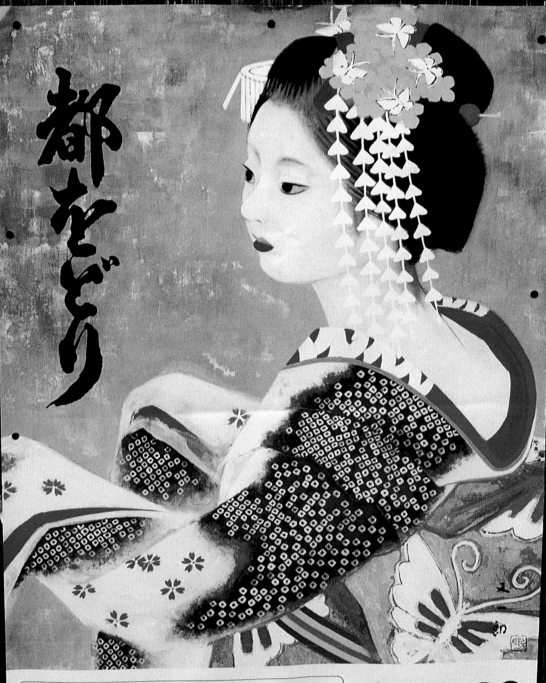

"In America, party invitations go out to 'Mr. and Mrs.' Here they don't; they go out to 'Mr. and Partner.' A geisha is my partner—kind of my wife, my sweetheart and my darling combined. You can't often change your wife, but you can change your partner anytime. How lucky I am to be a Japanese man!"

—Kyoto client

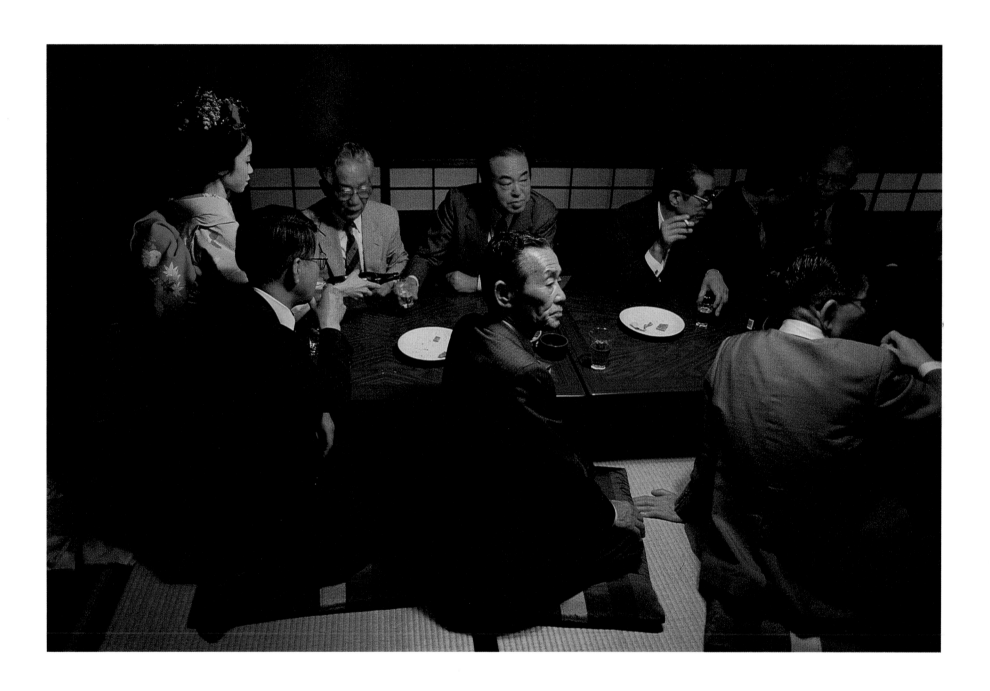

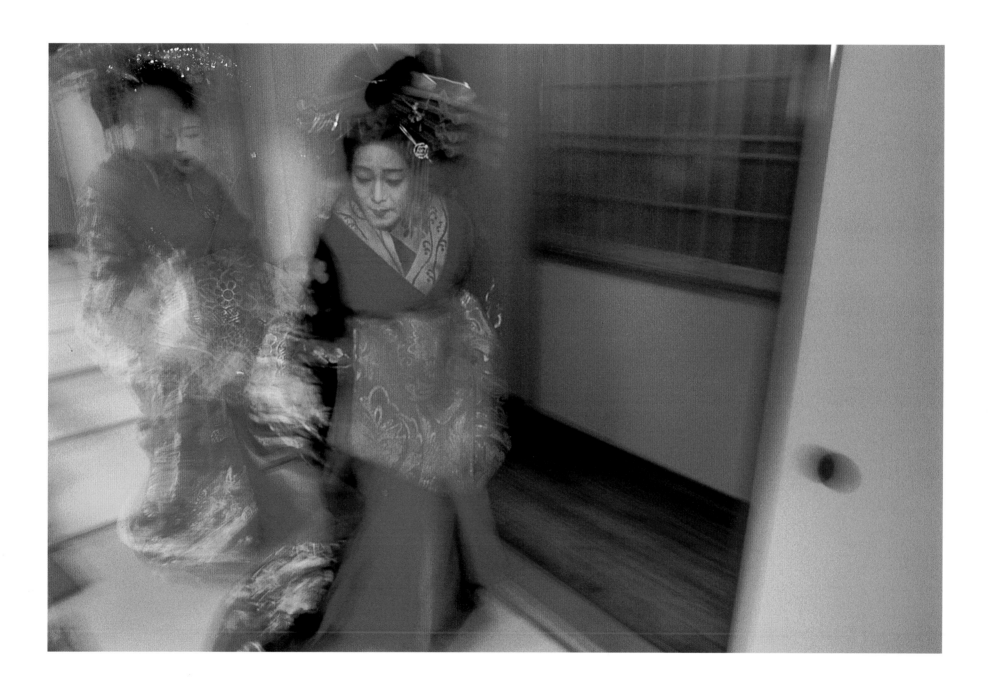

The spring wind whispers
Bring in fortune!
Fragrant plums breathe
Drive out devils!
Is it rain?
Is it snow?
I don't care—
We'll go on this evening and tomorrow too,
Drinking ginger sake.

<div align="right">

—GEISHA SONG

</div>

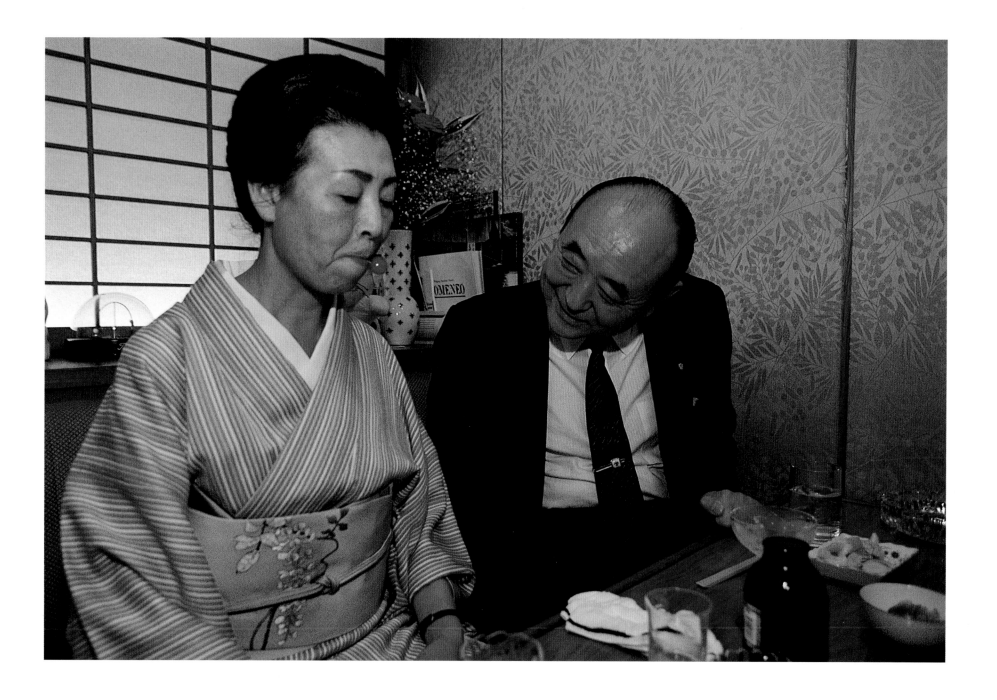

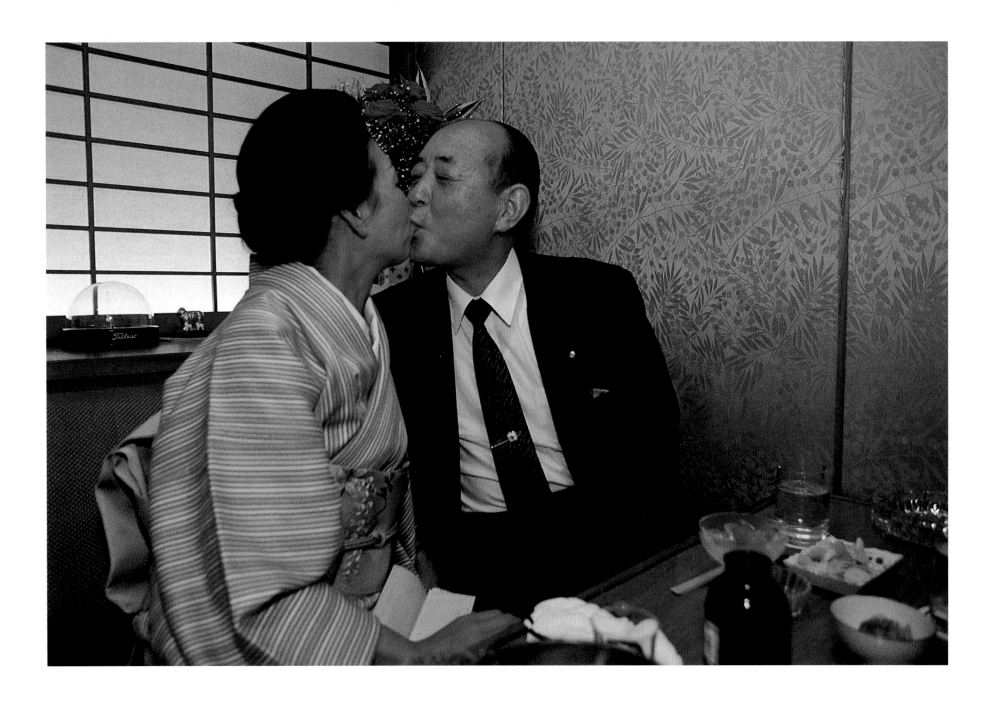

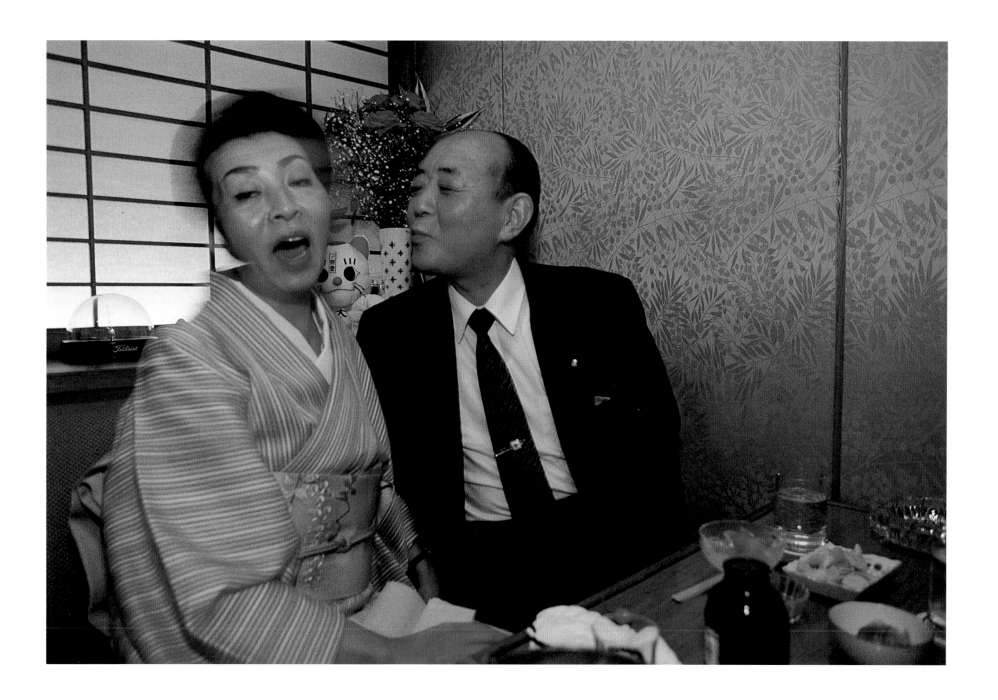

"My father played with geisha in Gion for seventy years—he started at thirteen and continued until he passed away at eighty-three. He brought me at age fourteen. That was my father's way, and my grandfather's way. . . .

"I want my family life to be peaceful, so I'm afraid to be charmed. I have no interest in remembering the names of the geisha. When I meet one who behaves and performs well and talks smartly and says, 'Oh, please remember my name,' I say yes, and she says, 'Please call me again,' and I say yes—but I won't do it. If I called her the next time, and again and again, as a male I could not trust myself. I want to keep my family happy and together, so I must make my own rules. But no one can say what will happen tomorrow.

"I have seen how geisha prepare their makeup, but I don't like to. I want the romantic ideal, not the reality. I don't want to know their tricks. I don't want to know their sad stories. I want to keep it as a dream, and they want to keep it as a dream for me. That's the business."

—Kyoto client